Disrupting Craft

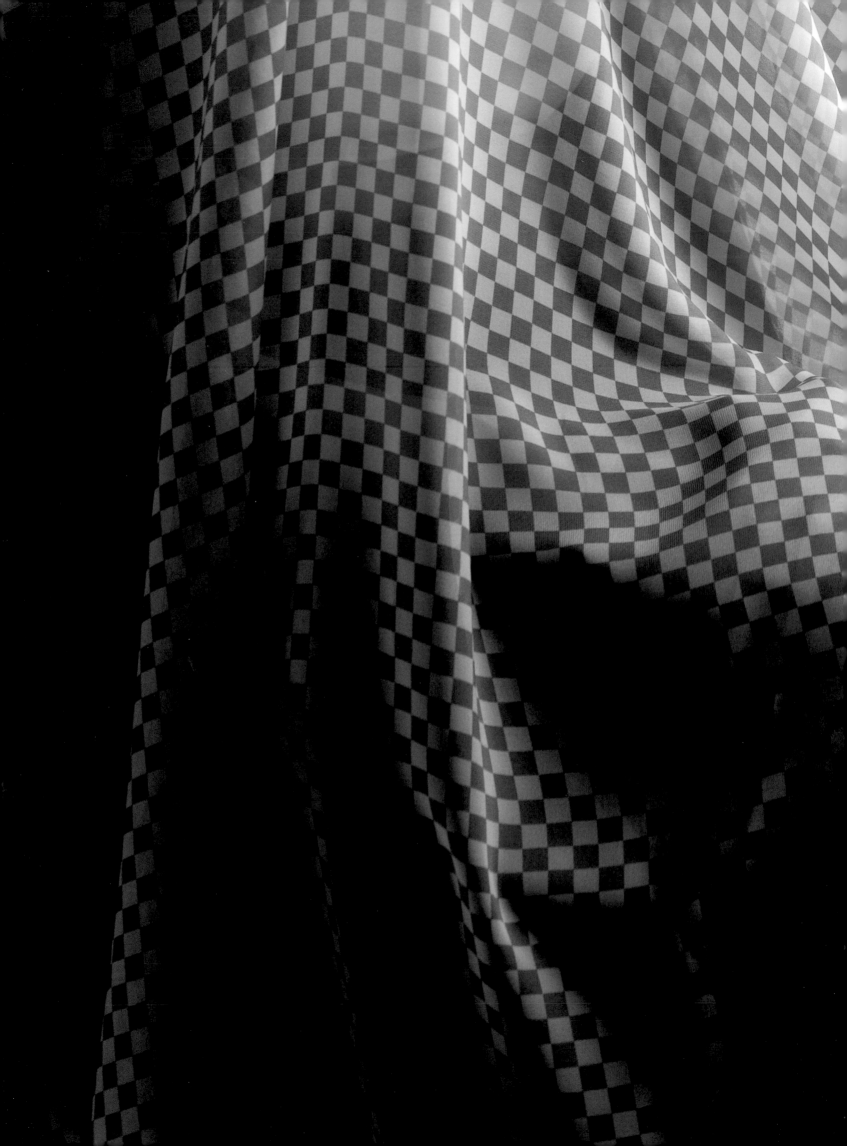

Renwick Invitational 2018

Disrupting Craft

Abraham Thomas

Sarah Archer

Annie Carlano

FOREWORD BY
Stephanie Stebich

Renwick Gallery of the Smithsonian American Art Museum,
Washington, DC, in association with D Giles Limited, London

The Ryna and Melvin Cohen Family Foundation Endowment provides support for the Renwick Invitational. The Cohen Family's generosity in creating this endowment makes possible this biennial series highlighting outstanding craft artists who are deserving of wider national recognition.

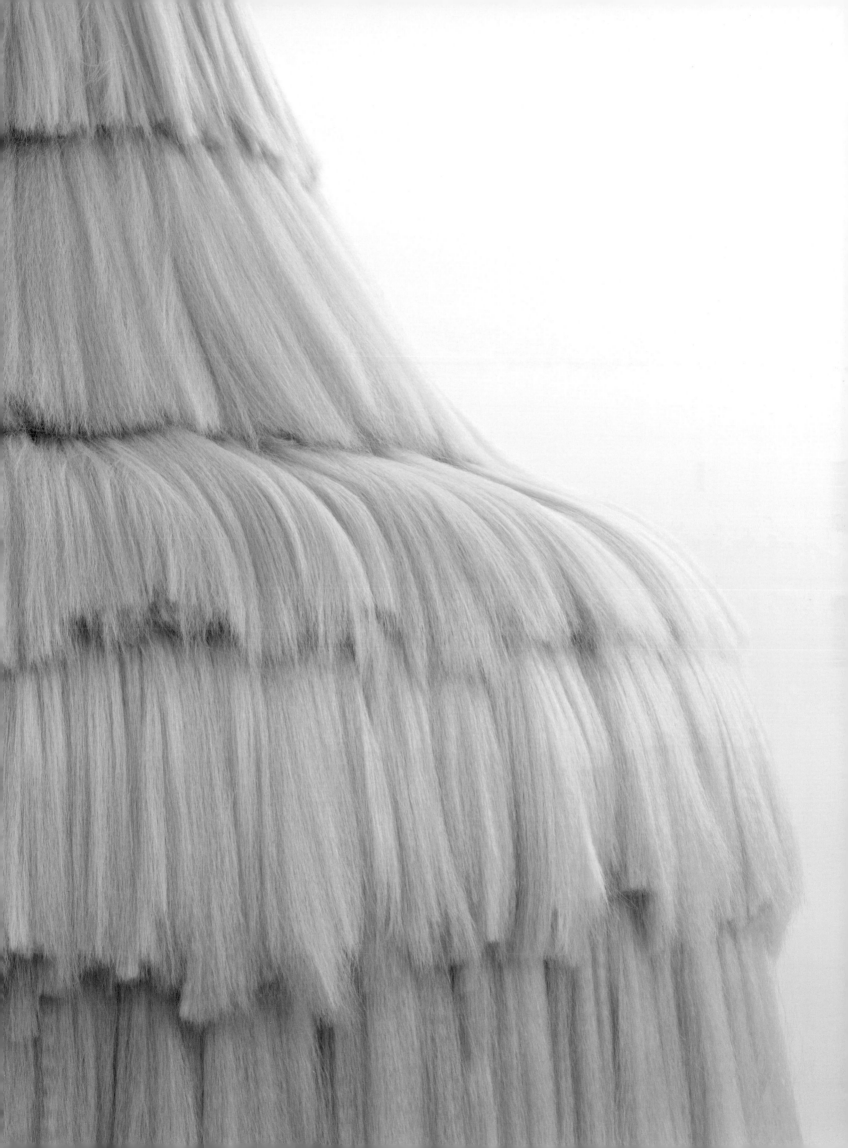

Disrupting Craft: Renwick Invitational 2018

by Abraham Thomas, Sarah Archer, and Annie Carlano, with a foreword by Stephanie Stebich

Published in conjunction with the exhibition of the same name, on view at the Renwick Gallery of the Smithsonian American Art Museum, Washington, DC, from November 9, 2018 through May 5, 2019.

© 2018 Smithsonian American Art Museum

Published by the Smithsonian American Art Museum in association with

GILES
An imprint of D Giles Limited
4 Crescent Stables
139 Upper Richmond Road
London
SW15 2TN
UK

Library of Congress Cataloging-in-Publication Data

Names: Renwick Invitational (Exhibition) (8th : 2018 : Washington, D.C.), author. | Thomas, Abraham (Museum curator) | Stebich, Stephanie A., writer of foreword. | Renwick Gallery, author.
Title: Renwick Invitational 2018 : disrupting craft / Abraham Thomas, Sarah Archer, Annie Carlano ; foreword by Stephanie Stebich.
Other titles: Disrupting craft | 2018 Renwick Invitational
Description: Washington, DC : Renwick Gallery of the Smithsonian American Art Museum ; London : in association with D Giles Limited, 2018. | "Published in conjunction with the exhibition of the same name, on view at the Renwick Gallery of the Smithsonian American Art Museum, Washington, DC, from November 9, 2018 through May 5, 2019." | Includes bibliographical references.
Identifiers: LCCN 2018026542 | ISBN 9781911282426 (pbk. : alk. paper)
Subjects: LCSH: Decorative arts—United States—History—21st century—Exhibitions.
Classification: LCC NK808.2 .R45 2018 | DDC 745.0973/0905—dc23 LC record available at https://lccn.loc.gov/2018026542

Smithsonian
American Art Museum
Renwick Gallery

The Smithsonian American Art Museum is home to one of the largest collections of American art in the world. Its holdings — more than 43,000 works — tell the story of America through the visual arts and represent the most inclusive collection of American art in any museum today.

It is the nation's first federal art collection, predating the 1846 founding of the Smithsonian Institution. The museum celebrates the exceptional creativity of the nation's artists whose insights into history, society, and the individual reveal the essence of the American experience.

The Renwick Gallery became the home of the museum's American craft and decorative arts program in 1972. The gallery is located in a historic architectural landmark on Pennsylvania Avenue at 17th Street, NW, in Washington, DC.

For more information, write to:
Office of Publications
Smithsonian American Art Museum
MRC 970, PO Box 37012
Washington, DC 20013-7012

Visit us at AmericanArt.si.edu.

Chief of Publications: Theresa J. Slowik
Designer: Nathaniel Phillips
Editor: Julianna C. White
Permissions Coordinator: Amy Doyel

Printed in Italy.

Cover: Dustin Farnsworth, *XLIII*, 2016 (see p. 73)

Frontispiece: Stephanie Syjuco, *Total Transparency Filter (Portrait of N)*, 2017 (detail; see p. 92)

Page 5: Tanya Aguiñiga, *Palapa*, 2017 (detail; see p. 37)

Page 10: Dustin Farnsworth and Timothy Maddox, *WAKE II*, 2017 (detail; see p. 78)

Page 13: Stephanie Syjuco, *Cargo Cults: Head Bundle*, 2016 (detail; see p. 84)

Page 14: Dustin Farnsworth, *Succession*, 2014 (detail; see p. 64)

Page 17: Sharif Bey, *Carved Blue Jar*, 2007 (detail; see p. 47)

Page 107: Tanya Aguiñiga, *Wall Hanging 3*, 2015 (detail; see p. 33)

Page 111: Sharif Bey, *Spiral Jar*, 2002 (detail; see p. 44)

Back cover: Stephanie Syjuco working on *The Visible Invisible: Antebellum South (Simplicity)*, 2018 (see p. 89)

Contents

Director's Foreword ——————————

The 2018 Renwick Invitational, the latest in a series of exhibitions spotlighting midcareer and emerging makers, grapples with the ways craft is reacting to the many social and cultural changes since the turn of the century. The theme of this year's selection — disruption — materialized out of discussions surrounding social practice, community engagement, cultural identity, and political activism, which are the motivations that bring the four chosen artists together. Over the past two decades, disruption in the world of craft has changed how makers think and create, interact with their media, teach their students, work in their studios, and create communities.

Abraham Thomas, the Fleur and Charles Bresler Curator-In-Charge at the Renwick Gallery, chose Sarah Archer, an independent curator, writer, and critic, and Annie Carlano, Senior Curator of Craft, Design & Fashion at the Mint Museum, as his fellow jurors. Together they have assembled works by four artists that are nuanced and powerful, full of intention, and wrestle with weighty questions. These artists probe and examine our social and cultural assumptions, bringing us with them on their journeys of discovery.

Many of Dustin Farnsworth's wood sculptures combine architectural elements with portraiture; he builds exquisitely detailed sculptures and then distresses and burns them, marring their perfection. As a storyteller, he begins with the histories of the people around him. He documents the economic distress that accompanied the decline of the automobile industry in Detroit, where he grew up, or the social and individual trauma inflicted by institutional prejudice and the results of gun violence, which he witnessed during his artist residencies in Madison, Wisconsin, and Charlotte, North Carolina.

Taking inspiration from the vessel forms traditional to potters and from beads often associated with African culture, Sharif Bey creates both functional and conceptual ceramic works. He investigates ritual and African American identity as an artist, teacher, and father. Growing up in a working-class neighborhood in Pittsburgh, Bey's dedication to art education stems from the incredible art programs he was offered within his community. Now a professor at Syracuse University, he brings a unique hybrid perspective to his art making and his teaching of arts education and leadership.

Los Angeles–based artist Tanya Aguiñiga draws on her own dual Mexican American identity to transgress political borders in her work. Using traditionally feminine fiber arts, she softens furniture designs and encourages strangers to come together to explore what separates cultures and countries. From backstrap weaving with Mayan women in Chiapas, Mexico, to bringing sustainability to communities across Los Angeles, she seeks to connect people through her art.

Stephanie Syjuco harvests the goods so common in our consumer culture to overturn assumptions and exploit ways we categorize people and things. A Filipino immigrant living and working in Oakland, California, Syjuco works across media, from photography to installations, to explore the global distribution of goods and neocolonialism. Her faux versions of everything from carpets to designer gear render the symbols we rely on to signal our identity to our social circles hollow and unsatisfying.

The Renwick Invitational series has run nearly two decades. This latest occasion owes its existence to the generosity of Ryna and Melvin Cohen, who have funded the series since 2005. The vision for this biennial exhibition that assembles groundbreaking artists working in craft today has had far-reaching consequences. The curators who have fulfilled this mission continue to guide us through a period of change and bring recognition to important artists doing vital work, as the traditions of craft are being transformed before our eyes into something both timeless and radically new. This year, the jurors have chosen a compelling and diverse group of artists who together, hold up a mirror that reflects their discoveries about social justice, shows us how to form lasting bonds within our communities, and helps us draw new maps of cultural identity. We take note of the remarkable works created, and the makers themselves who have developed artistic practices in the service of social change.

STEPHANIE STEBICH | The Margaret and Terry Stent Director
Smithsonian American Art Museum

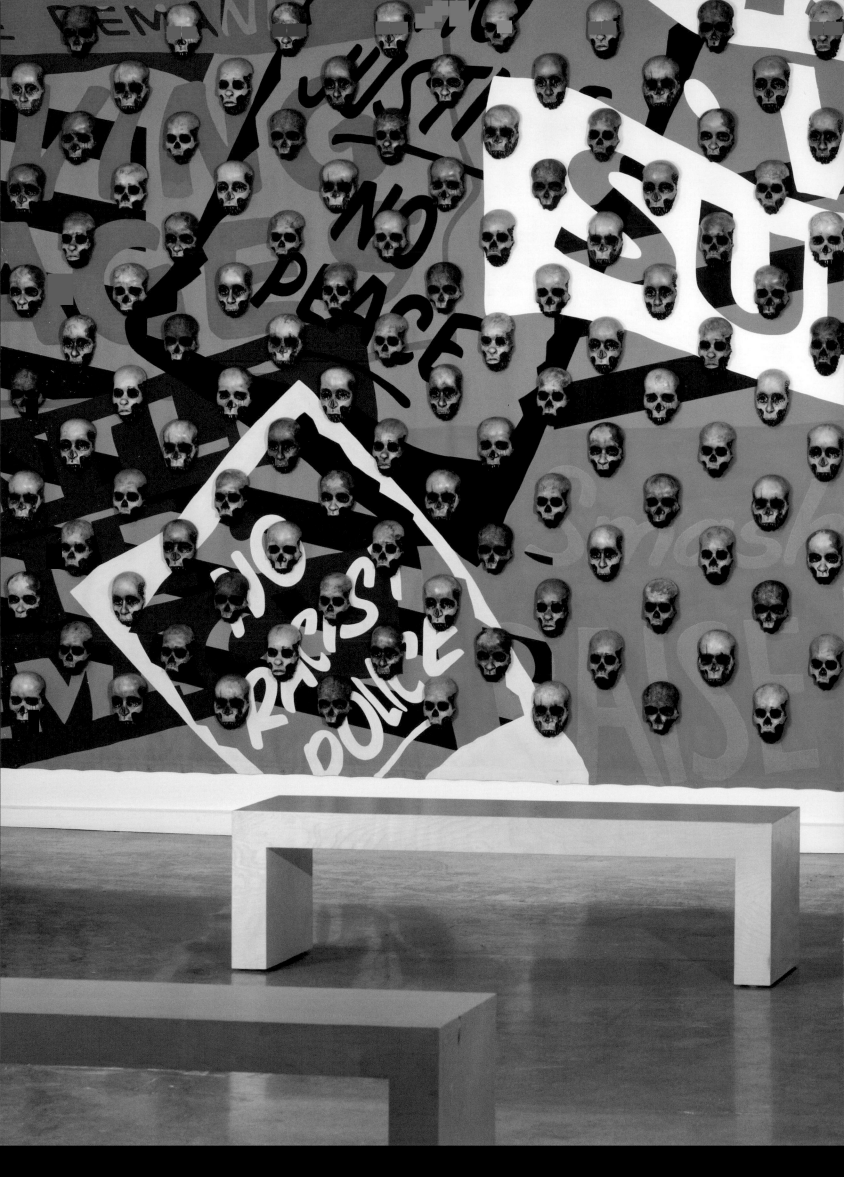

Acknowledgments

This exhibition and its catalogue would not have been possible without the valuable contributions of many people. My deep gratitude goes to Ryna Cohen and the Cohen Family Foundation for their dedicated support of the Renwick Invitational exhibition and publication series, and for making it possible for us to shine a light on these emerging and midcareer artists. I'd like to also thank the numerous lenders to the exhibition, both institutional and private individuals, who were generous enough to part with these extraordinary objects for a brief time, allowing us to share with the public the diverse range of these artists' careers to date.

I am indebted to my fellow jurors, Sarah Archer and Annie Carlano, who brought their expertise and passion to our initial discussions about the exhibition, responding thoughtfully to our themes of identity, social practice, and community engagement. They were instrumental in gathering this remarkable group of artists, and their insightful essays are a testament to their carefully considered perspectives. There were many other colleagues from outside the museum who helped with the exhibition's development, and far too many to list here, but for their vital contributions I would like to particularly thank Dana Funaro Hallonquist from Tanya Aguiñiga's studio; Heather McElwee, Executive Director of Pittsburgh Glass Center, who was extremely generous in commissioning new photography for a number of Sharif Bey's works for this catalogue; and RYAN LEE Gallery, New York, Volume Gallery, Chicago, Catharine Clark Gallery, San Francisco, and JF Chen, Los Angeles, for their support of the exhibition and the inclusion of works by Stephanie Syjuco and Tanya Aguiñiga.

My thanks go to our small, but dedicated, team at the Renwick — Nora Atkinson, Jim Baxter, Fern Bleckner, Elana Hain, Marguerite Hergesheimer, Robyn Kennedy, and Rebecca Sullesta, who were all key to the success of this exhibition. As with all of our projects, this was very much a collaborative effort, resulting from the hard work of many talented colleagues at the Smithsonian American Art Museum. Julianna White, Nathaniel Phillips, Amy Doyel, and Theresa Slowik came together to produce this wonderful publication. I'd like to thank Meghan O'Loughlin for designing such a beautiful exhibition, aided by Nathaniel who lent his graphic design flair not only to the catalogue but to the exhibition itself. My gratitude goes to Greg Bailey, Erin Bryan, Heather Delemarre, David Gleeson, Scott Rosenfeld, and all the other SAAM staff who endeavored, within a challenging schedule, to ensure that the works of these artists would be presented with the verve that they merited. A special thanks goes to Emily Peikin, my curatorial intern, who was involved in every aspect of the project, and whose assistance ensured a steady course for the Invitational — I am most grateful to you.

However, I should reserve the most important thank-you for the four artists in this exhibition — Tanya Aguiñiga, Sharif Bey, Dustin Farnsworth, and Stephanie Syjuco. From the very beginning, since my tentative emails to you all during late summer of 2017, you have shown such dedication to this exhibition — your energy and enthusiasm have been infectious. It has been so lovely to get to know you all during these past eighteen months. I have the utmost respect and admiration for your work, and I look forward to many future years of collaboration and friendship. Thank you for allowing us to share your stories with our audiences.

Finally, a personal note of gratitude to Erin Kuykendall Thomas, who originally lured me away from London to join her on this side of the pond. Thank you for all your support and for being there to bounce curatorial ideas around with — this is for you.

ABRAHAM THOMAS | The Fleur and Charles Bresler Curator-In-Charge, Renwick Gallery

currently living through. With an election cycle that has sharply divided the nation and a world finally woke to social justice, we find ourselves in a radically disrupted landscape. The three of us agreed that now seemed an opportune time to explore the relationship of craft with social practice — its role in community engagement and political activism, and how it can be used to work through cultural and personal identities during such division, crisis, and change. At times like this, how can we delve into craft's innate ability to be participatory and communal? Can it provide tools for resistance and social action? Does it have the means to help us reevaluate our history and be an agent for change?

My fellow jurors and I discussed work that had prodded and provoked us, by artists who we felt had pertinent voices begging to be heard. We whittled down our selections to a group of makers that felt simpatico in their sensitivities to cultural complexities, and united by a common sense of purpose. Our selected artists — Tanya Aguiñiga, Sharif Bey, Dustin Farnsworth, and Stephanie Syjuco — exploit the conceptual and collaborative toolkits of craft to react to the current political landscape.

Over the past ten years, we have witnessed a reevaluation of craft as an agent for social change and an instrument of political activism — from the 2010 *Gestures of Resistance* exhibition at the former Museum of Contemporary Craft in Portland, Oregon, to the work of scholars like Julia Bryan-Wilson's *Fray: Art and Textile Politics* (University of Chicago, 2017), and panel sessions hosted by the Critical Craft Forum at the annual conferences of the College Art Association, including Craft and Resistance (2018) and Craft and Social Practice (2014). The Renwick Gallery collections have also evolved through the acquisition of works, like the expressive ceramic cups made by Gulf War veteran Ehren Tool that aim to share the personal experience of the US soldier, the meticulously hand-stitched domestic products by Margarita Cabrera that cast a critical eye on the ethics of labor within factories along the US-Mexico border, and Kathryn Clark's *Foreclosure Quilt* that maps the urban housing impact of the 2008 economic crisis. As with Cabrera and Clark, the artist Theaster Gates (who trained as a potter and urban planner, and was featured in the Renwick's *40 under 40: Craft Futures* exhibition in 2012) delves into issues of race, labor, and urban development with participatory pop-up ceramic factories as part of his ongoing Soul Manufacturing

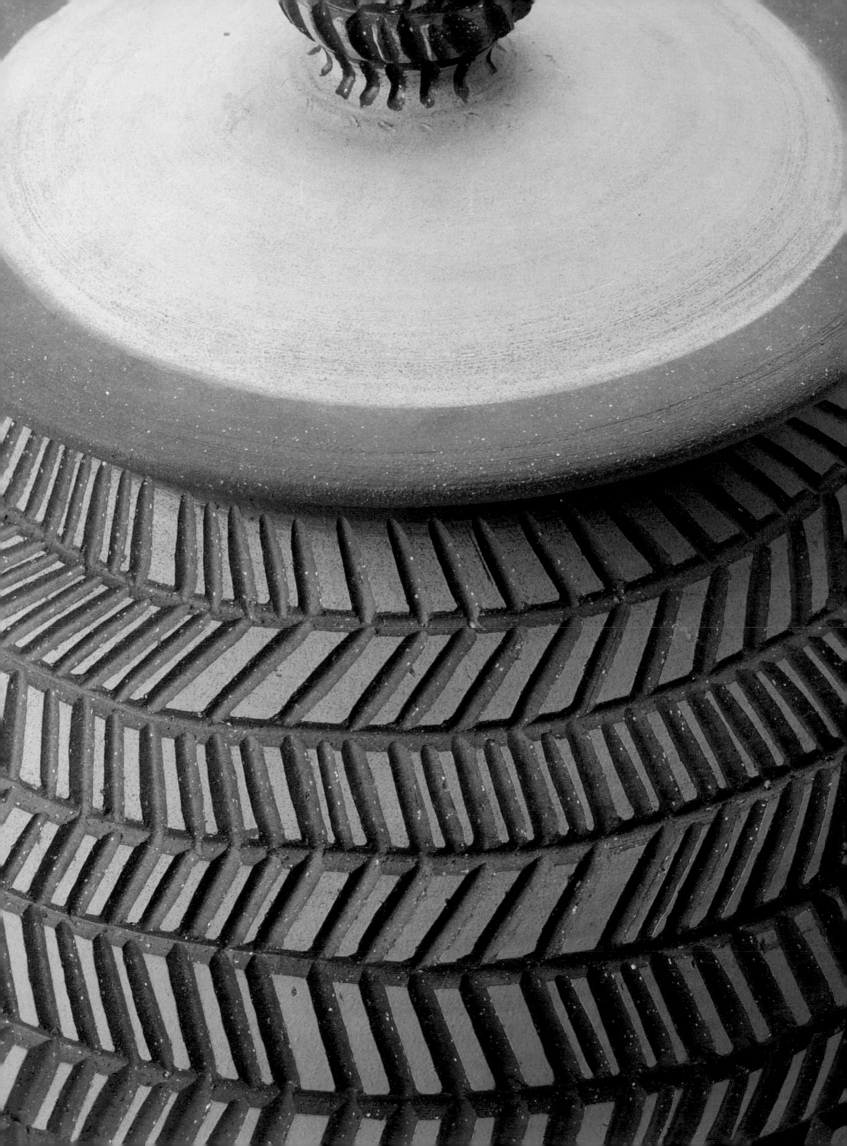

Corporation project. Similarly, ceramicist Clare Twomey's *Factory: The Seen and the Unseen*, a vast volunteer-led ceramics production line at London's Tate Modern in 2017, resulted in a form of public engagement that was part performance, part civic advocacy.

While the four artists in this year's Invitational wrestle with similarly thorny issues, one prevalent theme unites them more than any other — collective engagement. Tanya Aguiñiga is an artist, designer, and compassionate activist whose career is rooted in her many communities. Her collaborative projects initiate dialogue on identities; for example, how it feels to be a binational woman and mother living on the US-Mexico border. Her work, comprised mostly of natural fibers, is infused with a performative, and often surreal, quality that reveals raw personal narratives and universal feelings of vulnerability. She invites anyone to participate in her work, creating a community of action, and providing opportunities to artisans and lesser-known artists. As dedicated an educator and father as he is a ceramicist, Sharif Bey's work reflects the ways he interweaves these roles, continuously reinventing his artistic process. Ranging from the utilitarian to the sculptural and purely abstract, his objects exhibit a sensitivity to complex cultural histories, particularly how adornment in African societies has influenced contemporary African American society, and how identity can be shaped through status, power, and ritual. His attitude to making and teaching as a hybrid practice offers new models for cultural engagement, alternative forms of professional practice, and a refreshingly generous approach to democratizing access to craft skills. Dustin Farnsworth manipulates wood into haunting storylines that inhabit his intricately detailed portraits of today's youth. He aims to shed light on his subjects who suffer from inheriting societal and economic decay, the rise of gun deaths, and the oppression of marginalized communities. His most recent work incorporates audio recordings of young people from Charlotte, North Carolina, allowing his subjects to speak for themselves. As an installation artist, Stephanie Syjuco uses social practice and the tropes of craft to challenge our perceptions of "types" in contemporary America. She explores the manifestation of the handmade within digital processes and virtual networks of dissemination to manufacture complicated and contradictory fragments of American identities.

Aguiñiga, Bey, Farnsworth, and Syjuco challenge notions of craft. They weave elements of performance and installation art into their work, and use it as a means to reach out to their communities and to encourage tough conversations. Aguiñiga uses Incan quipu to invite commuters to record their crossing of the US-Mexico border. Syjuco questions cultural and political neutrality with an installation of objects representing art history, modernism, and ethnography. Bey uses his unique artistic process to increase access to meaningful art education within underserved communities, and Farnsworth incorporates oral histories from young people within his work, both making it a priority to help a disenfranchised generation.

The essays that follow explore the trajectories each artist has taken to discover how their craft can contribute beyond the confines of the art world and of their chosen media. In a global climate of increasing political and social discord, battle lines are being drawn around cultural identity, social equality, and institutionalized prejudice. The works of these artists not only offer piercing, insightful moments of contemplation on the rapidly transforming world around us, but — quite possibly — disrupts the status quo to bring us together, alter our perspectives, and lead us to a more hopeful, empathetic future.

ABRAHAM THOMAS | The Fleur and Charles Bresler Curator-In-Charge, Renwick Gallery

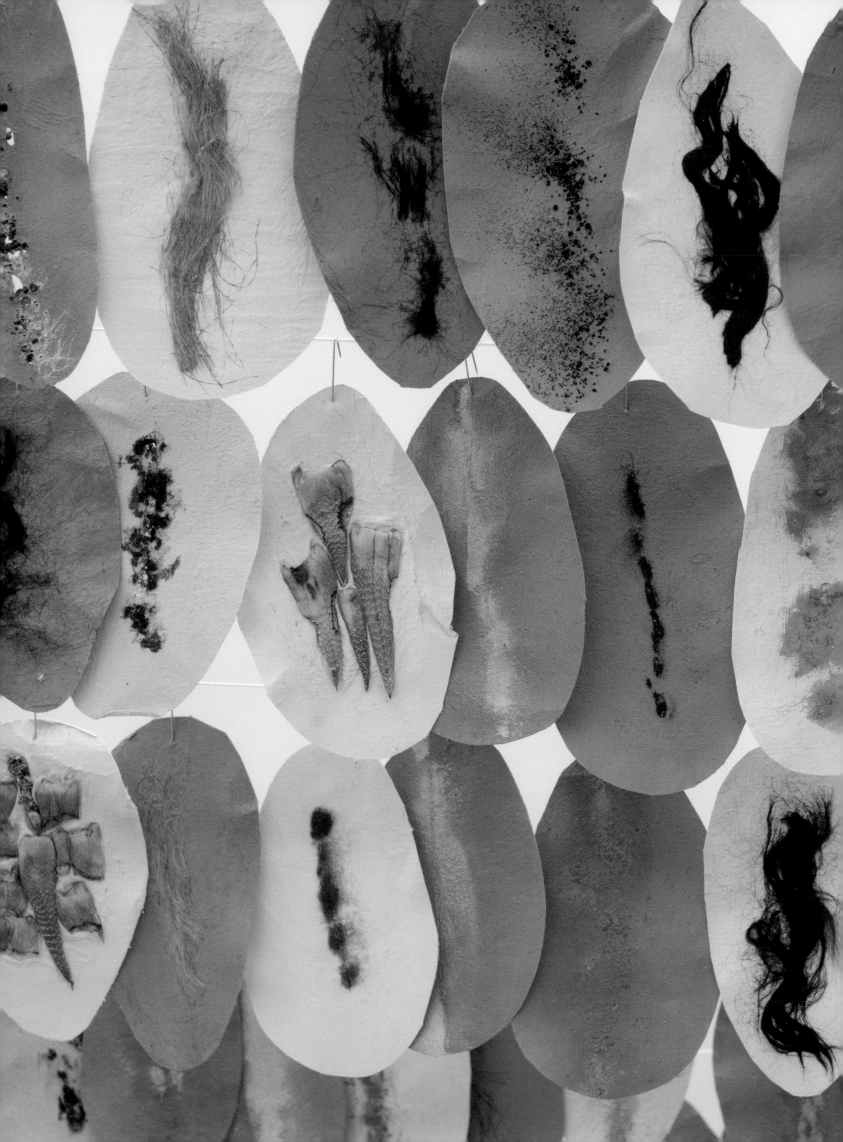

Tanya Aguiñiga

CRAFTING COMMUNITY, DESIGNING CHANGE

Nopal
(detail; see pp. 36 – 37)

Artist, activist, humanitarian, Tanya Aguiñiga operates in an interlaced realm of craft, process art, feminist art, design, and craftivism. She moves easily and energetically from making a chair to organizing a community project to designing a hotel lobby. With a passion for textiles and other materials of the earth, Aguiñiga finds inventive ways to address issues of prejudice, cultural conflict, gender disparities, and other pressing social injustices of our time. Her work is an extension of her life; she is a compassionate nurturer and mentor to her family, as well as an advocate for her extended family of close friends, students, interns, and communities — doing whatever it takes to influence change through resourceful and accessible art projects. Of the inability for art world professionals and others to define what she does and who she is, Aguiñiga has said, "I am whatever you need me to be."[1]

Of the many things she is, Aguiñiga is an agent for social change through community-based projects, particularly within the Latino and indigenous communities in Southern California (most emphatically her hometown border between San Diego and Tijuana), other US-Mexico border states, and Mexico. Since the 2016 presidential campaign, Donald Trump has spoken resolutely about his plan to build a monumental, impenetrable wall along the border. The proposed wall will be a barrier not just to illegal immigration, but to connectivity between Americans and Mexicans, including many, like Aguiñiga, who live binational lives. Additionally, on September 5, 2017, President Trump announced his plans to rescind the Obama-era DACA (Deferred Action for Childhood Arrivals) policy

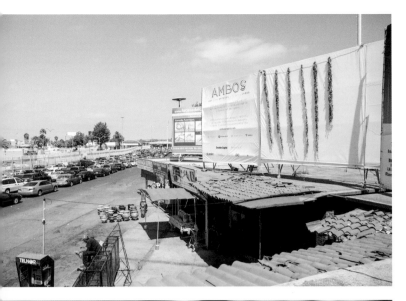

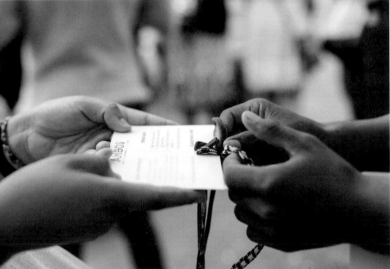

FIG. 1

AMBOS (Art Made
Between Opposite Sides)
project, Phase I, San
Ysidro Port of Entry, 2016

FIG. 2

Commuters tying
knots for the **Quipu
Fronterizo / Border
Quipu** AMBOS project

to the dismay of DREAMers (Development, Relief, and Education for Alien Minors Act participants) and their supporters. Aguiñiga's response has been, "Everything in my life has prepared me for this."[2] Since the majority of these 800,000 young immigrants are from Latin American countries, and 79 percent of the DACA recipients are Mexican and living in California, Aguiñiga amplified her already impactful AMBOS project (an acronym for Art Made Between Opposite Sides; *ambos* also means "both" in Spanish) (fig. 1), which seeks to create a greater sense of interconnectedness in the border region and address binational transition and identity through artist interventions and commuter collaborations.[3] The first project she created for phase one of AMBOS in 2016, *Quipu Fronterizo / Border Quipu*, references quipu, the knotted lengths of thin cord that the Incan and other Andean peoples used to count and gather data. Volunteers asked people at the border to make two knots (fig. 2) that were then joined together in giant quipu suspended from a billboard (fig. 3), recording the number of individuals passing through the bustling border. Phase two brought AMBOS to the Mexico, Arizona, New Mexico, and El Paso-Ciudad Juárez borders later that year. Phase three, completed in late summer 2018, has focused on the rest of Texas and Mexico with the goal of highlighting the similarities and differences of these unique border communities.[4]

Where the AMBOS project began — the San Ysidro Port of Entry, on the border of San Diego and Tijuana and the busiest land crossing border in the world — is a poignant reminder of the migrant worker story and the artist's own biography. Born in San Diego and raised in Tijuana, Aguiñiga crossed the border for eighteen years to go to school or work in the United States, a binational working-class kid. With family driving to jobs, and a grandmother living in San Diego, she had the opportunity for an education in the United States, albeit rising at four in the morning and getting to sleep late at night. Tijuana, an economically challenged yet bustling and entrepreneurial place, known as "the armpit of Mexico" and "purgatory," is where the scarcity of resources sparks an abundance

of ingenuity. Buildings are made of treasures from the trash heap, including fences fashioned from car doors — residents upcycling before it was a trend.

With a smile and a big heart, Aguiñiga was a change agent from her youth, seeking out playdates and initiating friendships by going door-to-door introducing herself to families. Surrounded by colorful Mexican decorative arts in her child-hood Tijuana home, she has always been drawn to vibrant hues — the highly saturated palette the result of natural plant, mineral, and insect dyes around her. Bold designs in the ubiquitous bright-colored striped blankets, embroidered clothing with flowers and birds, lace curtains, and patterned floor cloths combine to create a visually boisterous environment, rich with the cultural history of the ancient American people.

Aguiñiga's introduction to art activism began through the Border Art Workshop / Taller de Arte Fronterizo (BAM / TAF) when she was a nineteen-year-old student at Southwestern College in Chula Vista, California. Asked to join the group by her teacher Michael Schnorr, who had organized community-based projects to bring about social change in Afghanistan and elsewhere, she was in-trigued, and wound up working on projects on both sides of the Tijuana-San Diego

FIG. 3

Quipu Fronterizo /
Border Quipu displayed on the AMBOS billboard, August 20–28, 2016, at the Mercado de Artesanías, San Ysidro Port of Entry

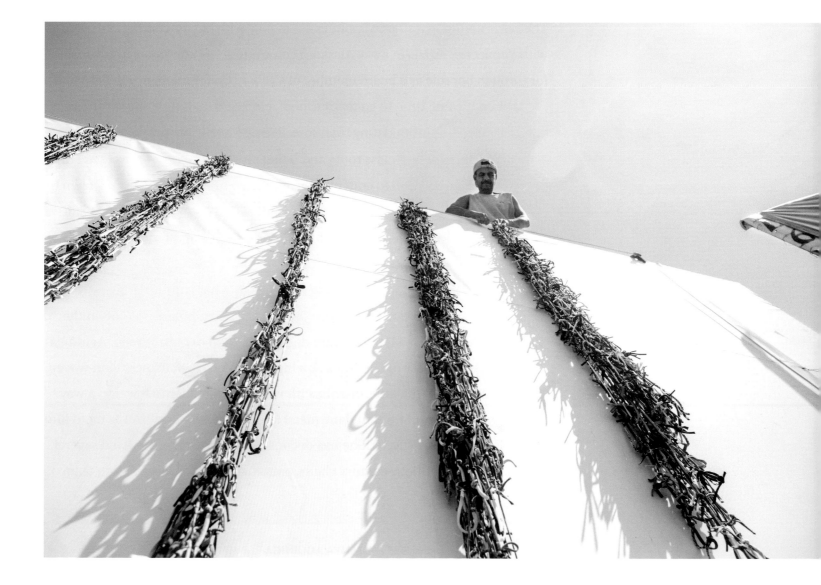

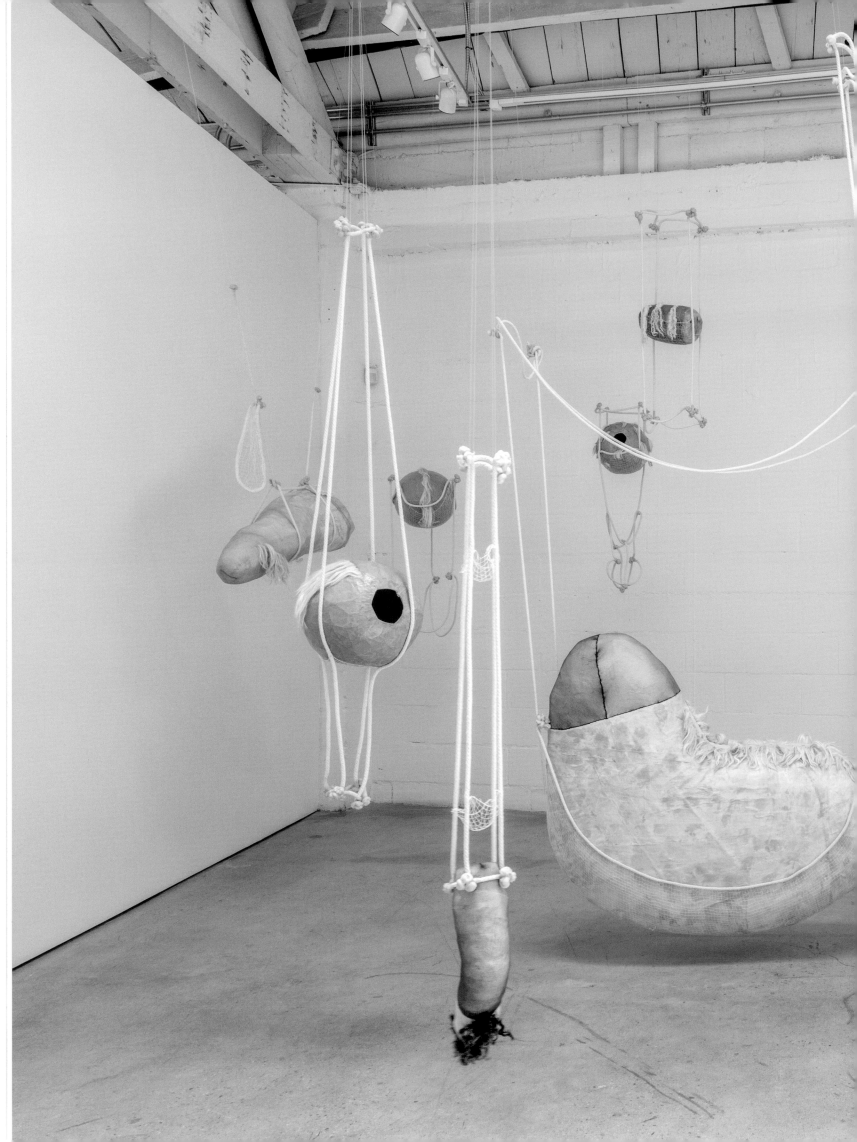

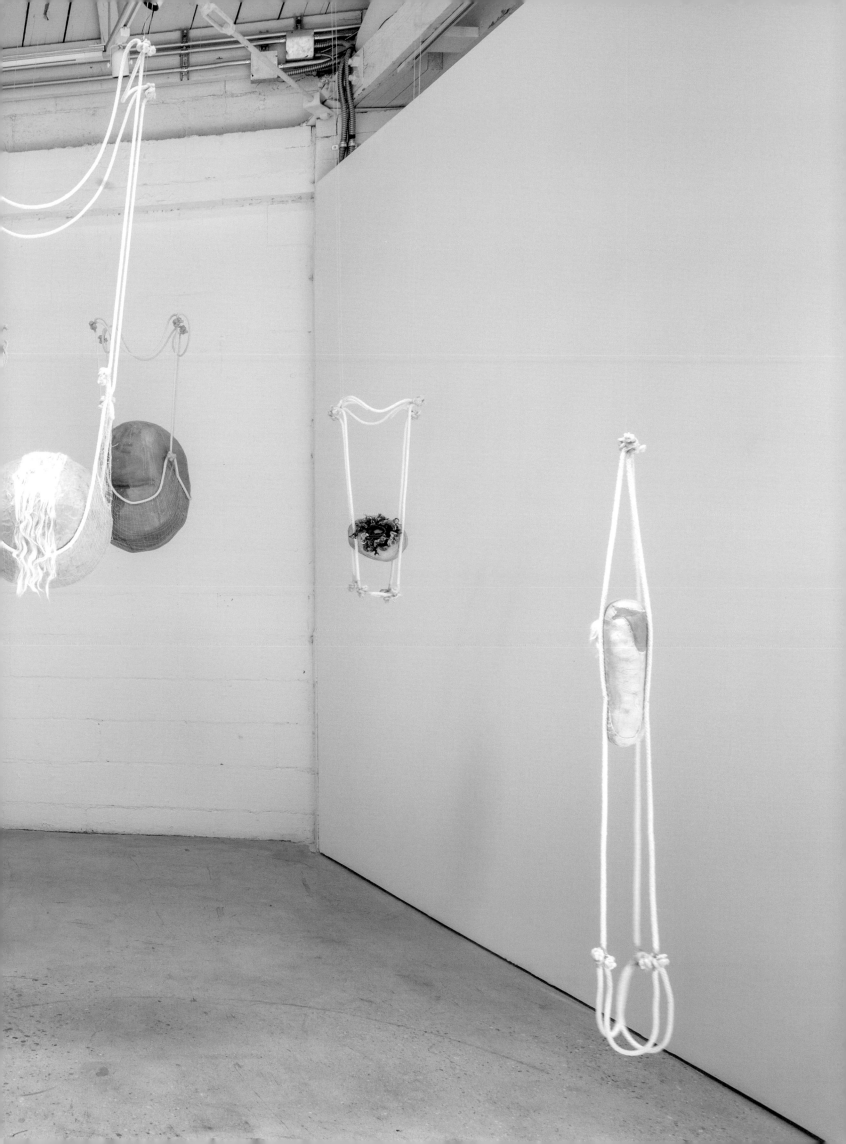

Left to right
FIG. 9

Beasts of Burden, 2016, cotton rope, cotton thread, foam, gauze, alpaca, nylon, and beeswax. Collection of the artist

FIG. 10

Gynic Dispossession 1, 2016, cotton rope, cotton thread, canvas, self-drying clay, alpaca, and beeswax. Collection of the artist

FIG. 11

Gynic Dispossession 6, 2016, cotton rope, cotton thread, canvas, self-drying clay, alpaca, and beeswax. Collection of the artist

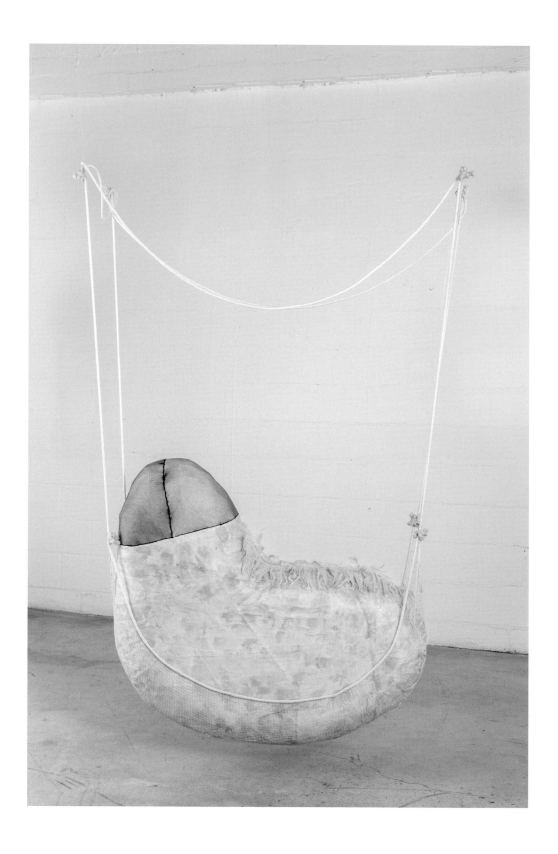

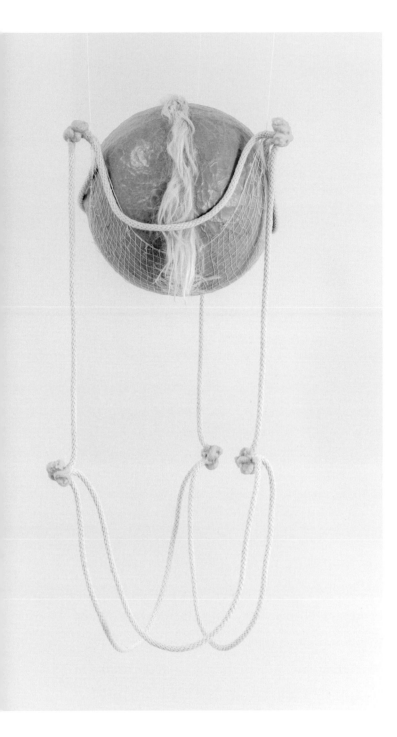

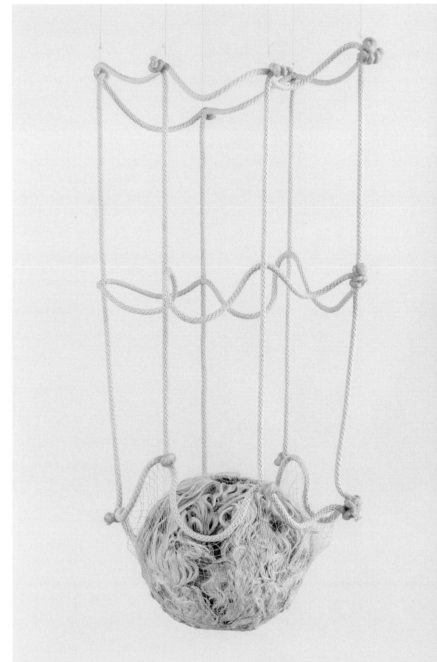

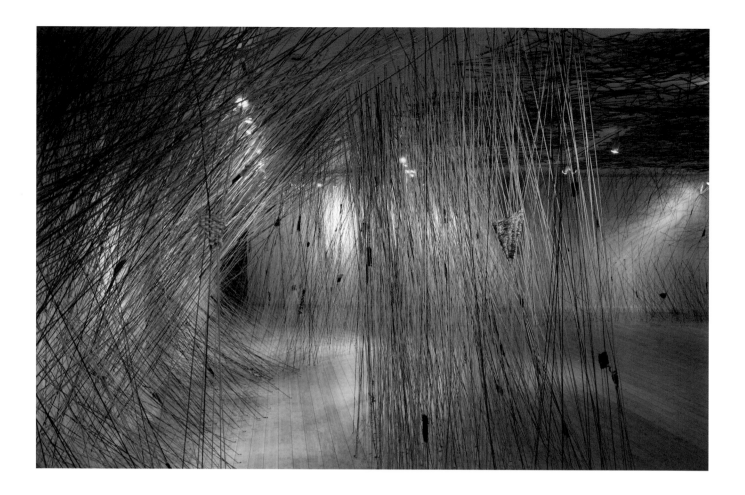

FIG. 12

Crossing the Line,
installation view, Craft
and Folk Art Museum,
Los Angeles, 2011

FIG. 13

Wall Hanging 3, 2015,
cotton, felt, and copper
electroplated terracotta.
The Mint Museum,
Charlotte, NC. Museum
purchase: Funds provided
by the Board of Directors
of the Mint Museum of
Craft + Design in honor of
Fleur Bresler

frequently. It was inspired by her experience of learning backstrap weaving from Mayan women in Chiapas, Mexico, a traditional technique where one end of the warp threads is tied around the waist of the weaver, and the other around an inanimate object, typically a tree. Weft threads are manipulated with sticks and the tension of the loom is maintained by the body. Adapting the fundamental aspect of the backstrap loom as a portable framework that can be installed anywhere, Aguiñiga used the floor, ceiling, and walls of the gallery at the Craft and Folk Art Museum in Los Angeles to anchor the threads that filled the space, creating a large-scale, colorful cobweb-like wonderland. Embedded throughout the installation were small weavings and furniture with thread components, creating a welcoming and playful space.

Aguiñiga turns to more biographical and personal work with a series of wall hangings drawing from her feelings surrounding first-time motherhood (fig. 13). Having a child caused the hyperenergetic artist to pause and reflect on her own family history. She uses materials that reference her binational childhood — nautical rope from San Diego and earthenware from Mexico (fig. 14). The copper electroplating may allude to the magic of the alchemical nature of birth. The soft, rich textures of the woven, interlaced, and sewn fibers are undyed, reading as an implied naturalness and purity (fig. 15). In these works, a visual relationship

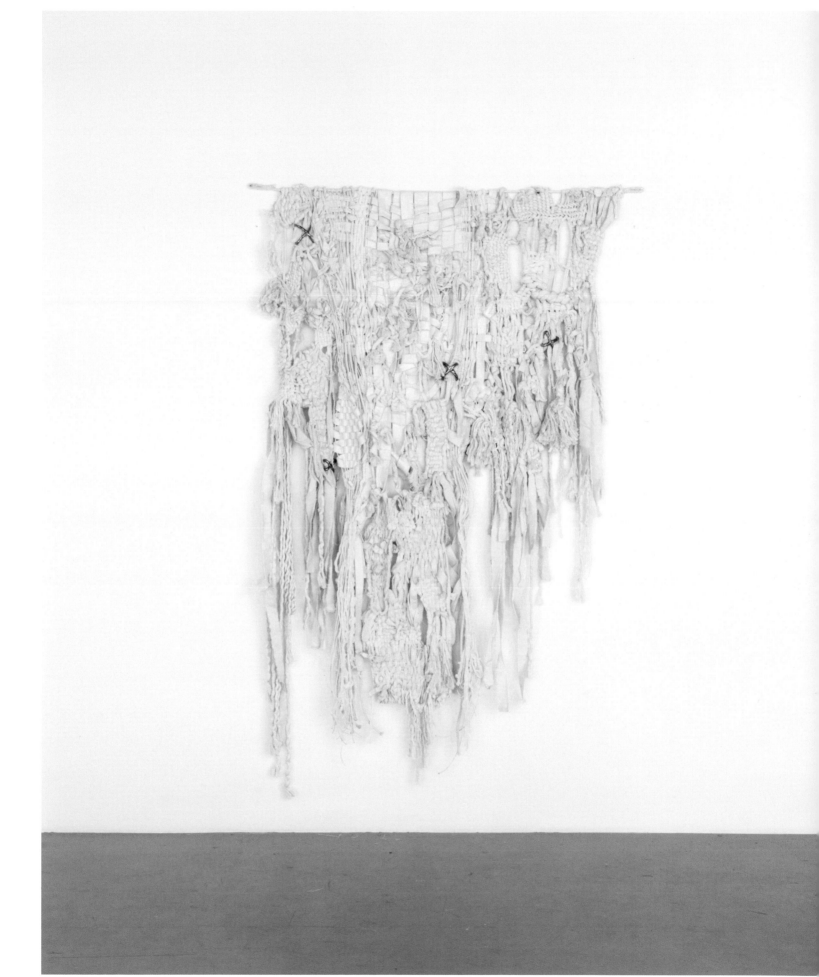

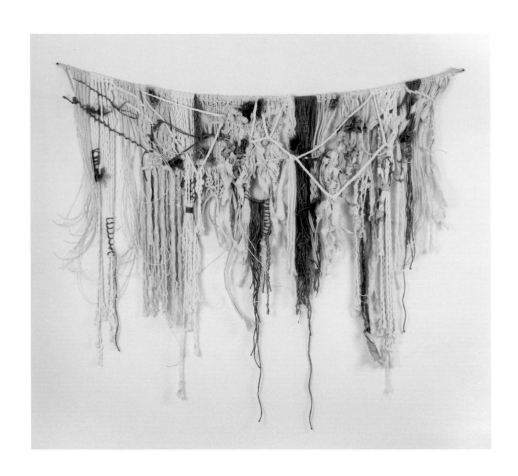

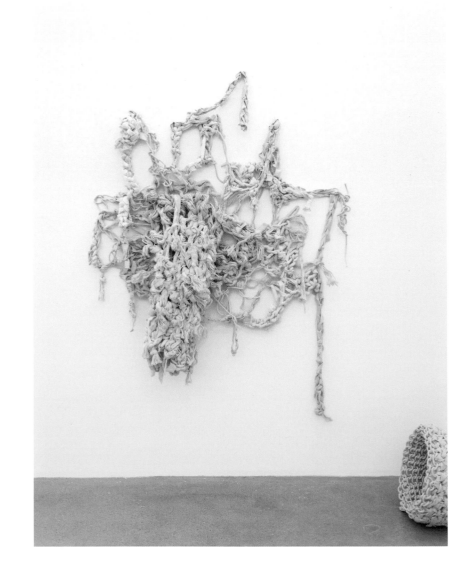

with the expressionistic fiber wall constructions of the 1960s and 70s emerges, by artists such as Peter and Ritzi Jacobi, Magdalena Abakanowicz, and others, who focused on the aesthetics of the technique and sought to free the form from the confines of warp and weft. Aguiñiga's wall sculptures do this, too, but with an embedded narrative and thoughts and questions about motherhood.[15] A few years into life with a daughter, the artist has been giving much thought to the genetic makeup of her child, from the maternal side. Aguiñiga knows little about her ancestors from archival documentation because of the turbulent migrations of her people, but stories of Yaqui relatives and of rape by French colonists have been passed down through oral histories. She thinks the latter is likely to be true, given the light skin and blue eyes of her mother, and her own fair skin and hair.[16]

The ambiguous, tumultuous, and astounding revelations from her search for identity manifested in the 2017 installation *Reindigenizing the Self* (fig. 16), shown at Volume Gallery in Chicago. Seeking to learn more about *mestizaje* (Spanish for miscegenation, the mixing of ancestries) and her family's origins beyond the apocryphal, she became fascinated with Mesoamerican history and mythology. In the *Popol Vuh*, the sacred book of the Quiché Mayan people, Aguiñiga found kinship with the protagonists of the creation myth, the Hero Twins, Xbalanque and his brother Hunahpu.[17] The interconnectedness of plant, animal, and human permeates the epic. Copal scented the air and the sound of Aguiñiga's footsteps walking in Nogales, a city on both sides of the Mexico-Arizona border, was the soundtrack of her exploration into this part of her identity. Inspired by these connections, she created a series of *Nopal* (fig. 16; background), prickly pear cactus pads, or paddles, the vernacular for the young ellipsoidal branches of the plant, which lined the walls of the gallery and surrounded the viewer. Made of a clay body mixed with abaca fiber backed with cheesecloth, some of these thin-skinned paddles have flax, horse hair, or human hair — hers, her daughter's, and her sister's — all embedded in a vertical line. Others have dried or live cochineal bug markings smashed onto the paddles, metallic surface treatments, or bas-reliefs of succulents from the artist's garden. Combining these forms of life into the paddles, which appear more vaginal than vegetal, the artist makes a statement about both identity in place — her desert home — and gender. Each paddle has a slightly different "skin tone," depending on whether she used porcelain or stoneware in the clay body, indicating the various skin tones of the diverse Mexican population. In this installation, two *Palapas* (fig. 16; foreground)

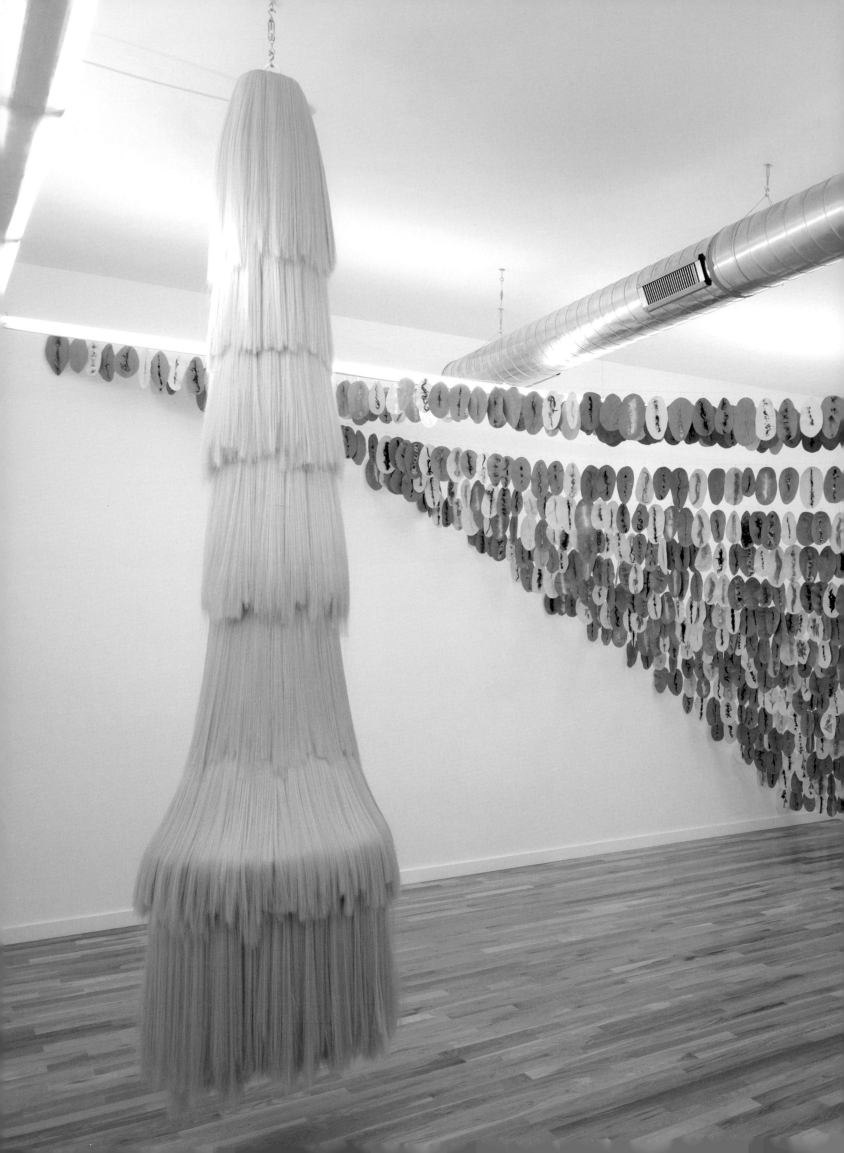

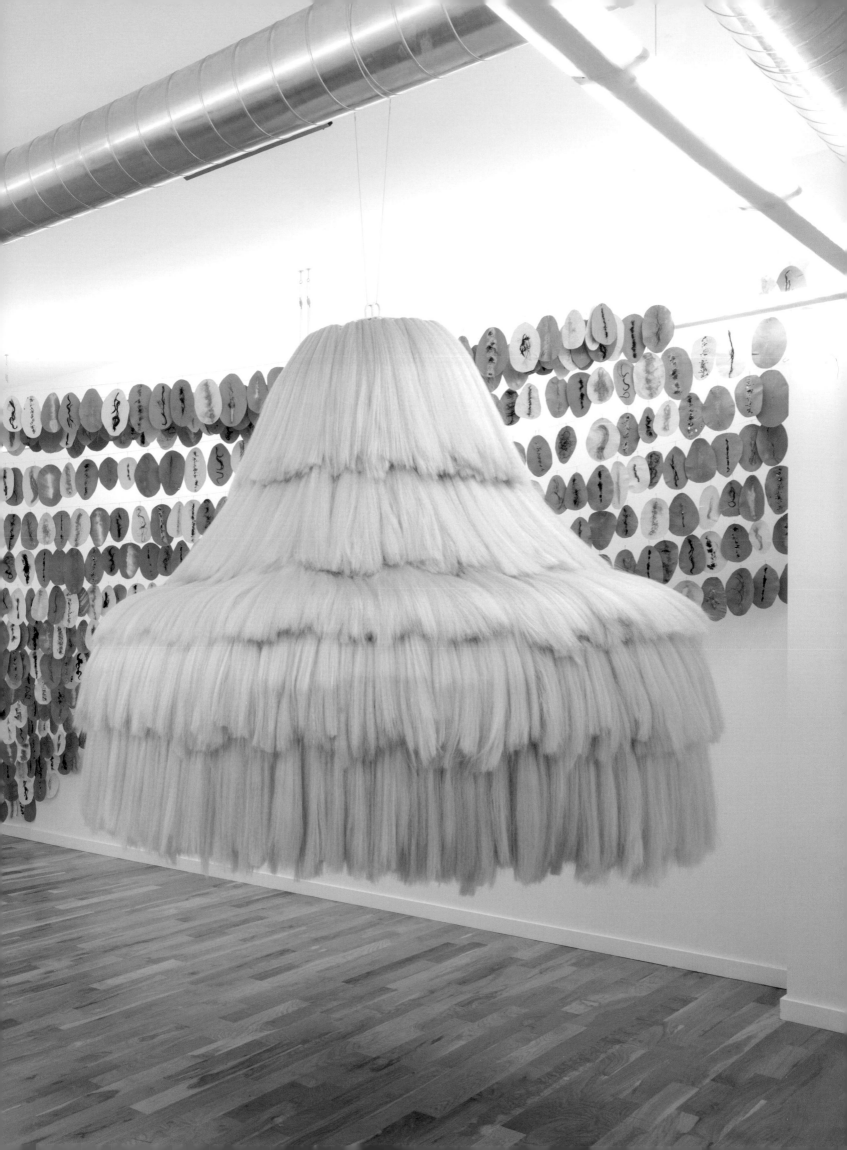

Previous pages
FIG. 16

Reindigenizing the Self,
installation view, Volume
Gallery, Chicago, 2017

Background

Nopal, 2017, abaca
pulp, clay, alpaca,
flax, succulents, iron,
horsehair, cochineal (live
and dead), copper, gold,
and human hair. Courtesy
Volume Gallery, Chicago

Foreground

Palapas, 2017, powder-
coated steel and
synthetic hair. Courtesy
Volume Gallery, Chicago

Opposite page
FIG. 17

Tierra, 2014, nylon, soil,
leather, thread, and vinyl.
Collection of the artist

suspend from the ceiling, named for the thatched huts with open sides that dot the beaches of Mexico. Woven by Mexicans but used mostly by tourists, the *palapa* can be seen as a symbol of the artist's ambiguous identity as someone who navigates the worlds of *palapa* maker and user, of and outside both cultures.

These questions of identity, and the surreal nature of being a binational at this moment in the history of the United States, have spurred Aguiñiga to dig into craft traditions to find a visual language that attracts and unites us. Extracting a universal vocabulary from a personal narrative, her performances and object making are carefully plotted creative mechanisms that introduce us to the "other" through their ability to challenge our beliefs and grab our emotional core. For this author, there is no more profound example of Aguiñiga's extraordinary ability to get to the heart of the matter than *Tierra* (fig. 17). Of this oversized warp and weft tube filled floor covering, the artist has written:

> Based on soil being our true ground, and my belief that objects with history are more lasting in our households, *Tierra* is made of woven soil from places that are important to me. The piece explores our attachment to soil/land as regards to proprietorship and war. In making an incredibly personal floor covering, I went on a journey to reconnect with places that haunt my dreams. The places my soul believes is home, and places that have shaped who I am now — despite wanting to distance myself from painful memories. . . . Each site was photographed and has an identification tag in writing and in coordinates to encourage people to map out their geographical location.[18]

Like a true *maga de la tierra*, Tanya Aguiñiga is advancing dialogue to further human rights and opportunity for all. ANNIE CARLANO

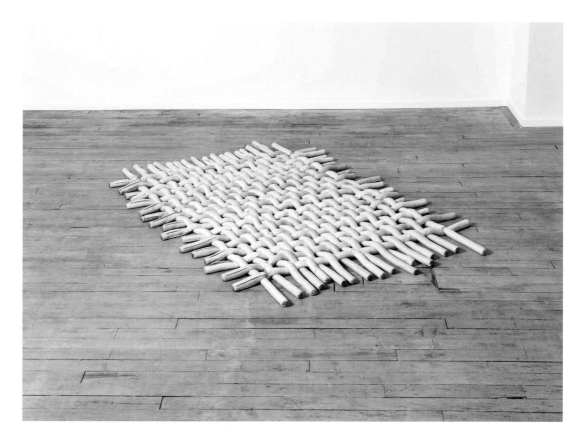
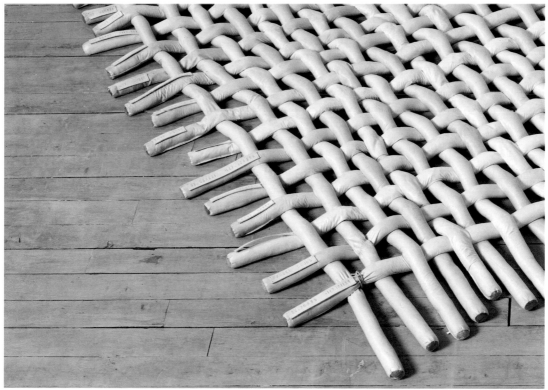

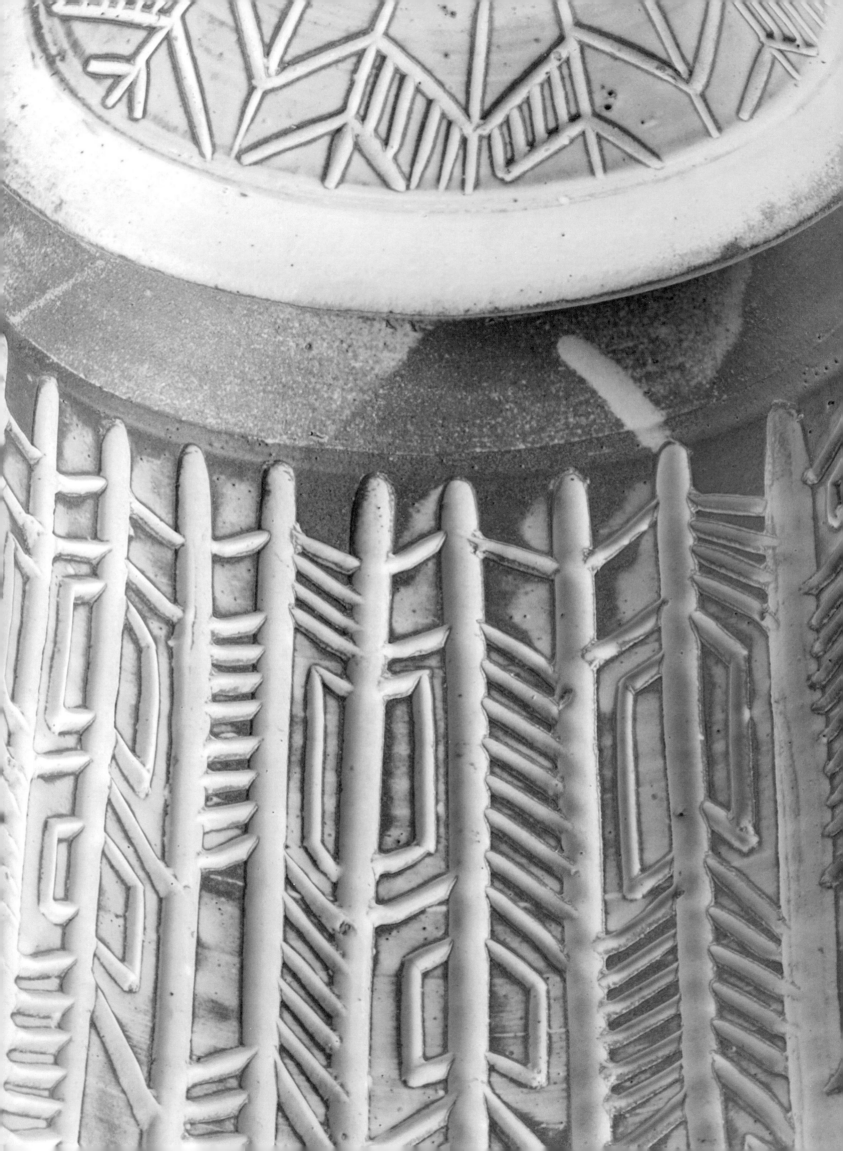

Sharif Bey

BLURRED BORDERLINES

Feather Jar
(detail; see p. 47)

Sharif Bey's work occupies a thought-provoking, liminal space between the sculptural and the functional, the expressive and the subdued, the civic and the personal. He creates objects that are difficult to pin down, slippery in their ability to defy neat categorization. He darts between quietly pensive functional pots (fig. 1), large beaded necklace pieces, dramatic figurative sculptures pierced with nails and ceramic shards, and abstract organic forms (fig. 2). Unifying these seemingly disparate areas of production is a persistent line of inquiry into personal and cultural identity, symbols of status and community, notions of power and ritual, and contested narratives of global history.

At the heart of this ambiguity lies Bey's ability to combine creative and professional practice within his working and family life. He serves as a dual associate professor at Syracuse University in the College of Visual and Performing Arts and the School of Education. He maintains a studio space on campus, just steps away from where he teaches. Having a studio embedded within his teaching space allows him to combine theory with practice, illustrating his own "model of open engagement."[1] "Modeling professionalism" is an essential part of his toolkit as an educator, and offers an opportunity for his students to peek behind the curtain of what it means to be a professional artist.[2]

> My teaching explores the role the visual arts can play in building community within the context of a classroom. I believe that making has a unique way of opening pathways and creating platforms for what can otherwise be

difficult conversations about our respective differences and lived histories. Engaging people in my studio facilitates the crystallization of ideas. If I am making I am as content working with dozens of students as I am alone in my studio.[3]

Much of Bey's philosophy on education can be traced back to his years growing up within a large African American family in a working-class neighborhood of Pittsburgh. During the 1980s, the city offered a rich menu of community, museum, and pre-college art programs for aspiring young artists like Bey. He attended the same Saturday classes at the Carnegie Museum of Art that Andy Warhol had as a child, and then, at the age of fourteen, Bey was recruited by the Manchester Craftsmen's Guild for their after-school apprenticeship program in pottery. "What inspired me to take the plunge into art education was that I wanted change. I felt everybody should have what I'd had, that there was a disparity in how people were being taught, and that opportunities were being missed to connect people." Bey's doctoral dissertation, "Aaron Douglas and Hale Woodruff: The Social Responsibility and Expanded Pedagogy of the Black Artist," examined how "certain kinds of studio environments can open up a space for different kinds of learning."[4]

The teaching artists at the Manchester Craftsmen's Guild, most of whom were recent MFA graduates, became mentors to Bey. "It didn't feel hierarchical. Although I was only a high schooler, they didn't mythologize the modes of cultivating a career in the arts; they normalized these modes so it became tangible and necessary." The Guild also had a world-class visiting artists program that introduced Bey to some of the leading contemporary ceramic artists in the country. "I fired with Paul Soldner, painted on pots with Ed Eberle, drew on pots with Ron Myers, and discussed the depths of form and functionality with Warren Mackenzie."

His time at the Manchester Craftsmen's Guild opened up ways for him to explore his personal identity as well. "I was raised in a rambunctious household with six brothers and five sisters, where privacy was limited and personal possessions were contested. . . . MCG served as a retreat . . . through my work in the pottery studio I found purpose and calmness that was not available to me anywhere else."[5] The possibility to explore a career in art became a positive and viable alternative for Bey. Most of his older brothers had gone on to become welders, but Pittsburgh's industrial decline during the 1980s severely curtailed

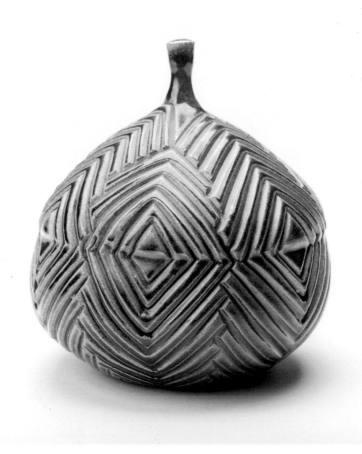

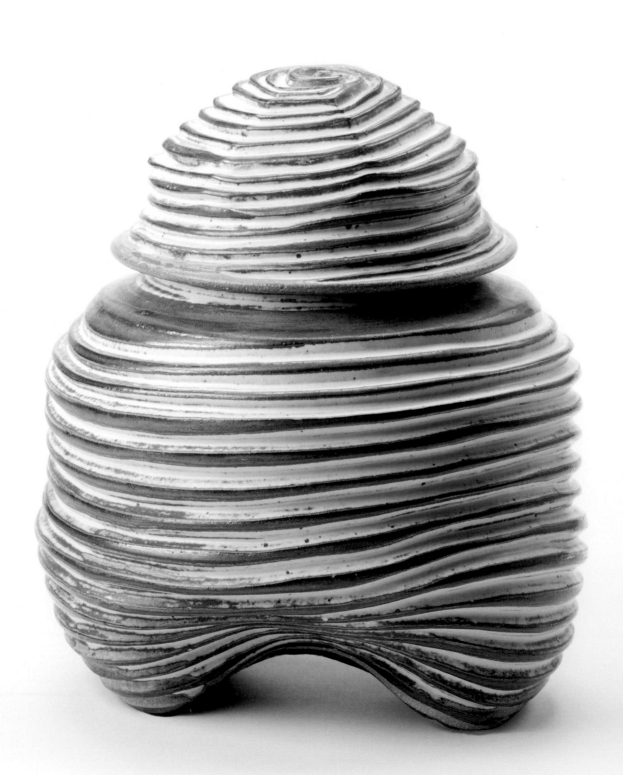

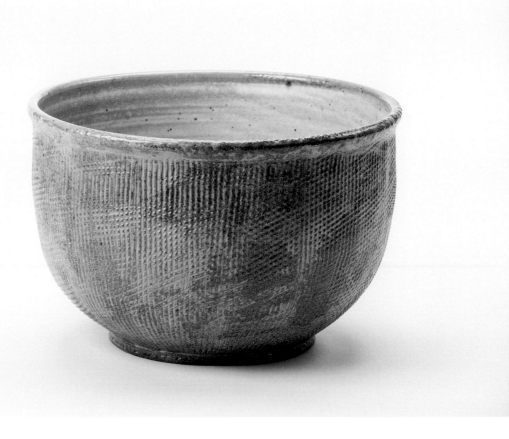

job opportunities, and the racially charged policies of the war on drugs happening at the same time were starting to have a grave effect within his community. As Bey puts it, "My salvation was making pots." By tenth grade, he was serious about becoming a ceramicist. "When I say serious, I'm talking about NCECA and *Ceramics Monthly* posters all over my room. That was my rock band."[6]

When asked about the appeal of working with ceramics over other materials, Bey is refreshingly direct and insightful, and shows how connected he is with his medium. "The immediacy of clay is probably what attracts me the most. I am a mud person. I am not as calculative as others who invest hours in pyrotechnics and glaze chemistry. I just like playing in clay and seeing what it reveals. I am not particularly scientific in my approach." Revealing a parallel with his home life, Bey remarks wryly, "I am the same in my kitchen. . . . It's just a pinch of this and a pinch of that. As my mother once told me when I inquired about her piecrust — 'We are not bakers. We are homemakers. Eyeball the water.'"

His functional clay pots (figs. 3–8) have provided a crucial backbone throughout his career, serving as the foundation for his work and teaching. Bey considers the vessel to be his "orientation," and the hum of the pottery wheel to be something that grounds him. Despite their simple forms, Bey succeeds in embedding these subtle, everyday works with rich layers of historical and cultural

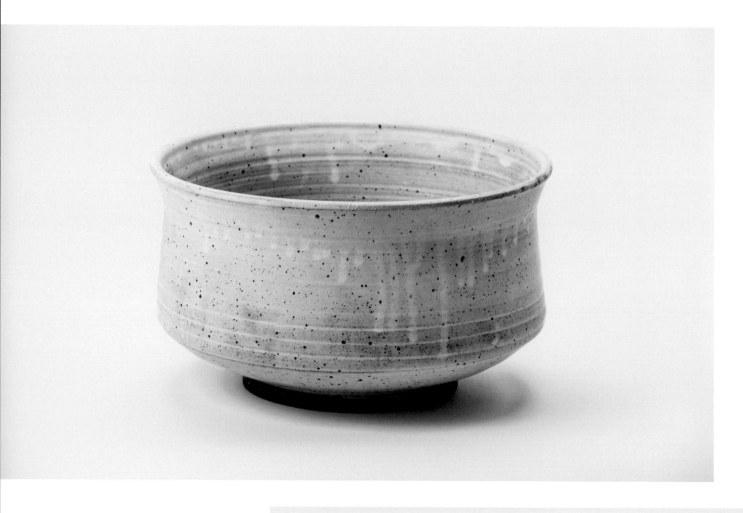

FIG. 5

White Bowl, 2014, stoneware. Collection of Anna Yetman

FIG. 6

Yellow Jar with Stripe Texture, 2015, salt-fired stoneware. Collection of the artist

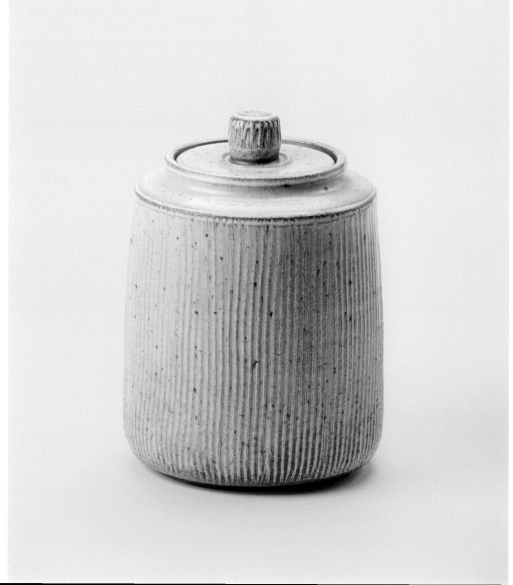

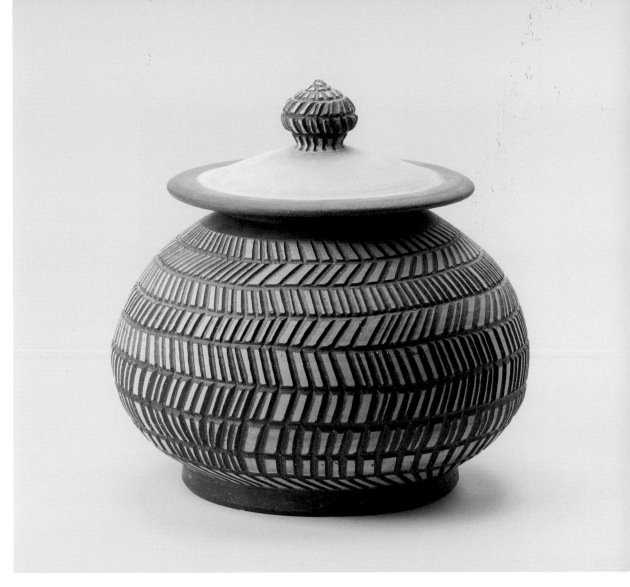

FIG. 7

Carved Blue Jar, 2007,
black stoneware.
Collection of the artist

FIG. 8

Feather Jar, 2002,
stoneware. Collection
of Burl J. F. Moone III

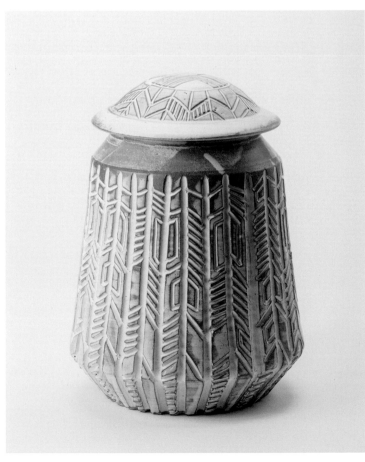

FIG. 9

One of Bey's satellite
studios, ca. 2005

Opposite page
FIG. 10

Ripened Banana, 2014,
vitreous china and mixed
media. Carnegie Museum
of Art, Pittsburgh;
Purhcase, gift of Walter
Read Hovey, by exchange

meaning, drawing upon shapes and ornamentation from sources as diverse as ancient American pottery, European modernist design, African ceramics, and Native American textiles. While his *White Bowl* and *Yellow Jar with Stripe Texture* articulate the forms and textures of modern ceramicists Lucie Rie and Hans Coper, the stark geometric contrast of *Carved Blue Jar* seems evocative of the plaited fiber casings of Central African water bottles.

A key turning point in Bey's practice came with the arrival of children. As he describes it, "working away from home felt extremely selfish," so rather than prioritizing his studio work over his family responsibilities, he set up a studio in his basement in an attempt to integrate these two aspects of his identity. However, he was "constantly rushing upstairs to help with the kids" and it was impossible to generate any momentum. "It became increasingly critical to find a way to balance my energies and set aside a reflective time and space for making. I needed to adjust my attitude, my aesthetic, and my work ethic. I knew that there must be a studio rhythm that was conducive to my lifestyle." Determined to make it work, Bey abandoned the large thrown jars and teapots with intricate surfaces for which he became locally known and began working on a smaller scale, primarily focusing on form. "My hope was to produce pieces that I could complete in one sitting. I did not want to depend on any spatial or equipment needs, and I wanted mobility and immediate access to the kids while I worked."

Bey set up satellite studios all around his house (fig. 9), each complete with basic clay tools, brushes, and a large mound of clay, working on top of shipping quilts to keep surfaces clean. "I developed a prolific system that enabled me to produce reasonably sized pieces in three to five minutes, employing a combination of pinch and coil techniques."[7] It was not long before he had stockpiled hundreds of small pots, which became the base elements for his beaded forms (fig. 10) — a body of sculptural work that Bey has circled back to over a number of years, each time exploring different scales, materials, technical applications,

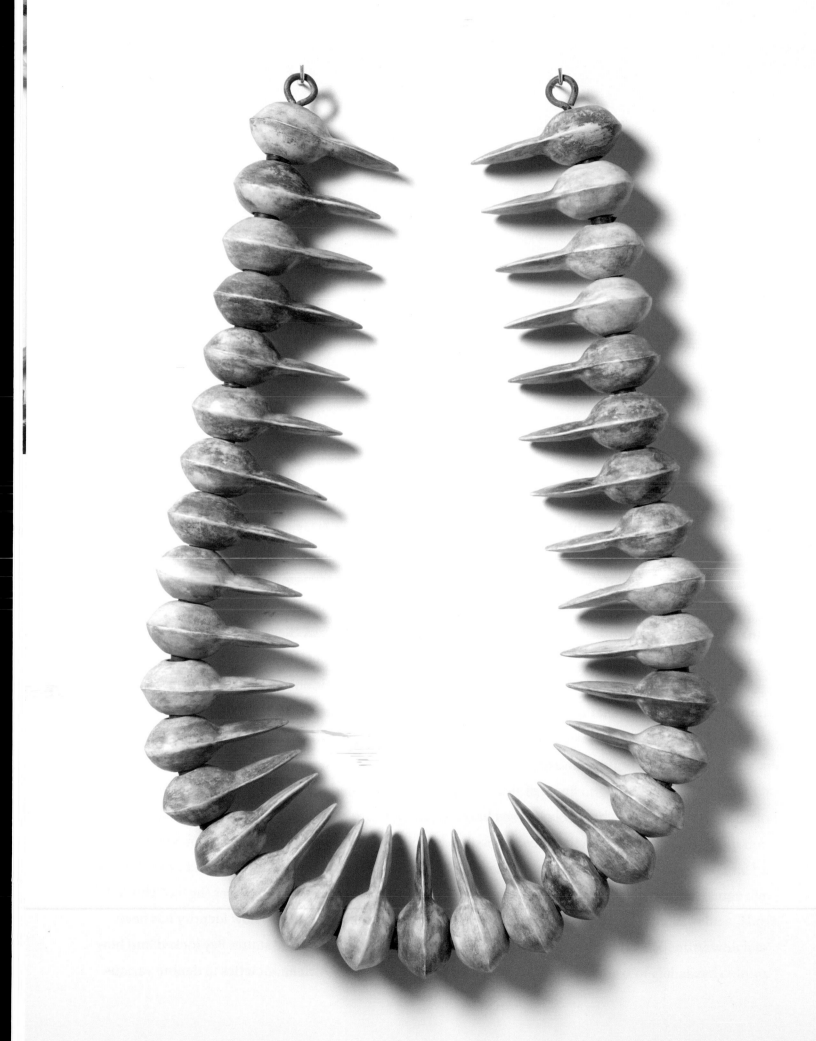

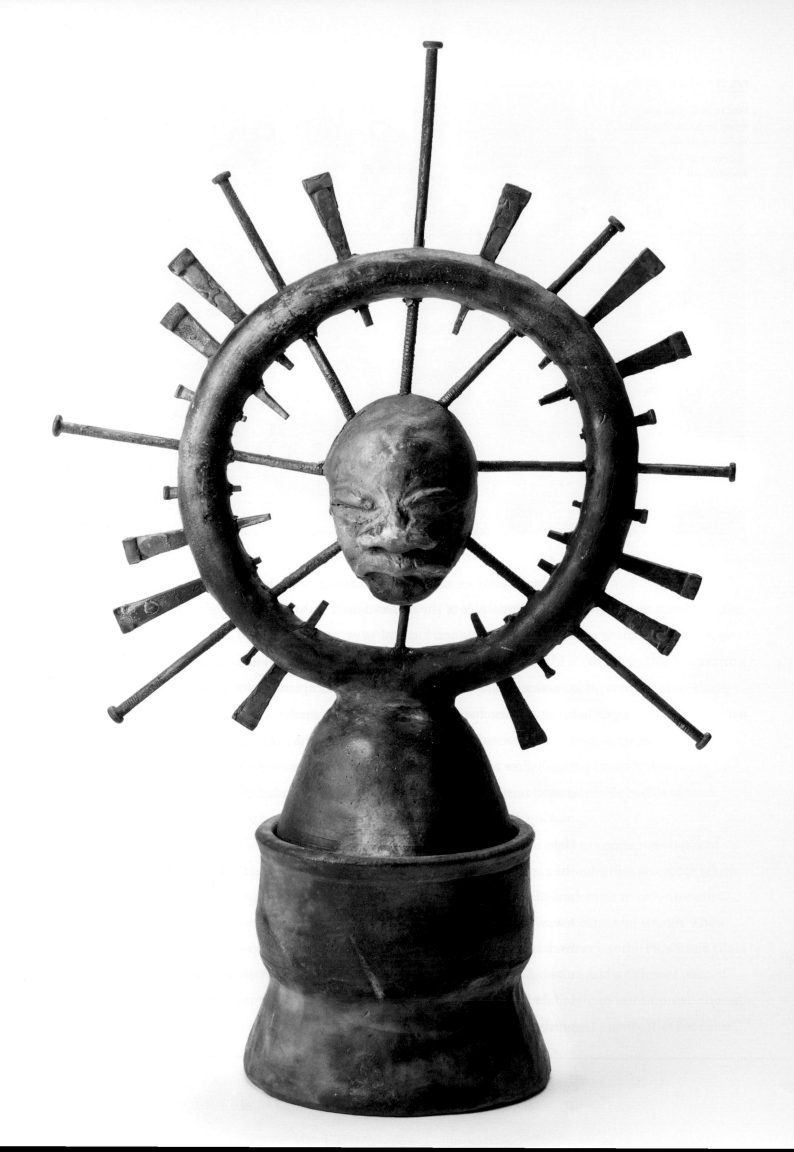

Opposite page
FIG. 24

Star Child Series #1,
2017, earthenware,
mixed media, and nails.
Collection of the artist

FIG. 25

Sax Bandit, 2011,
earthenware and mixed
media. Collection of
the artist

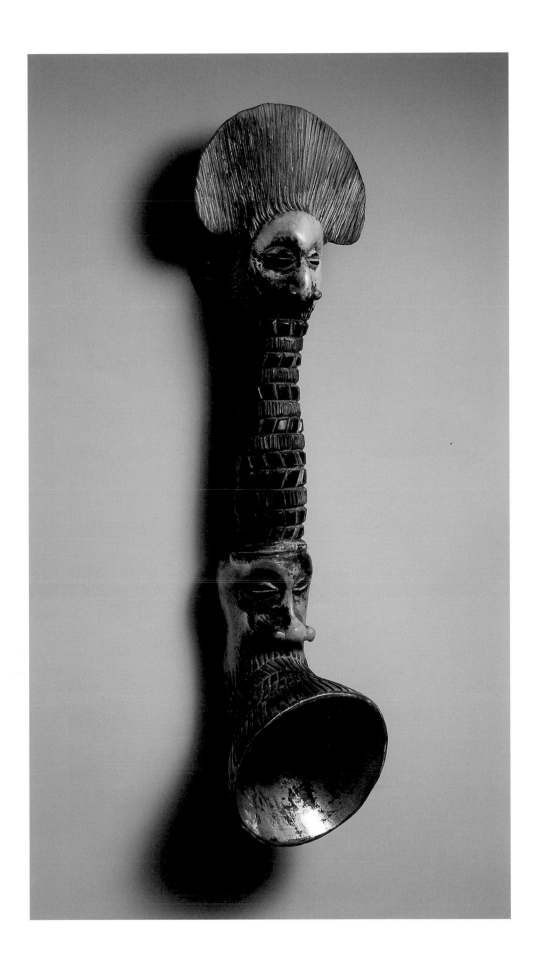

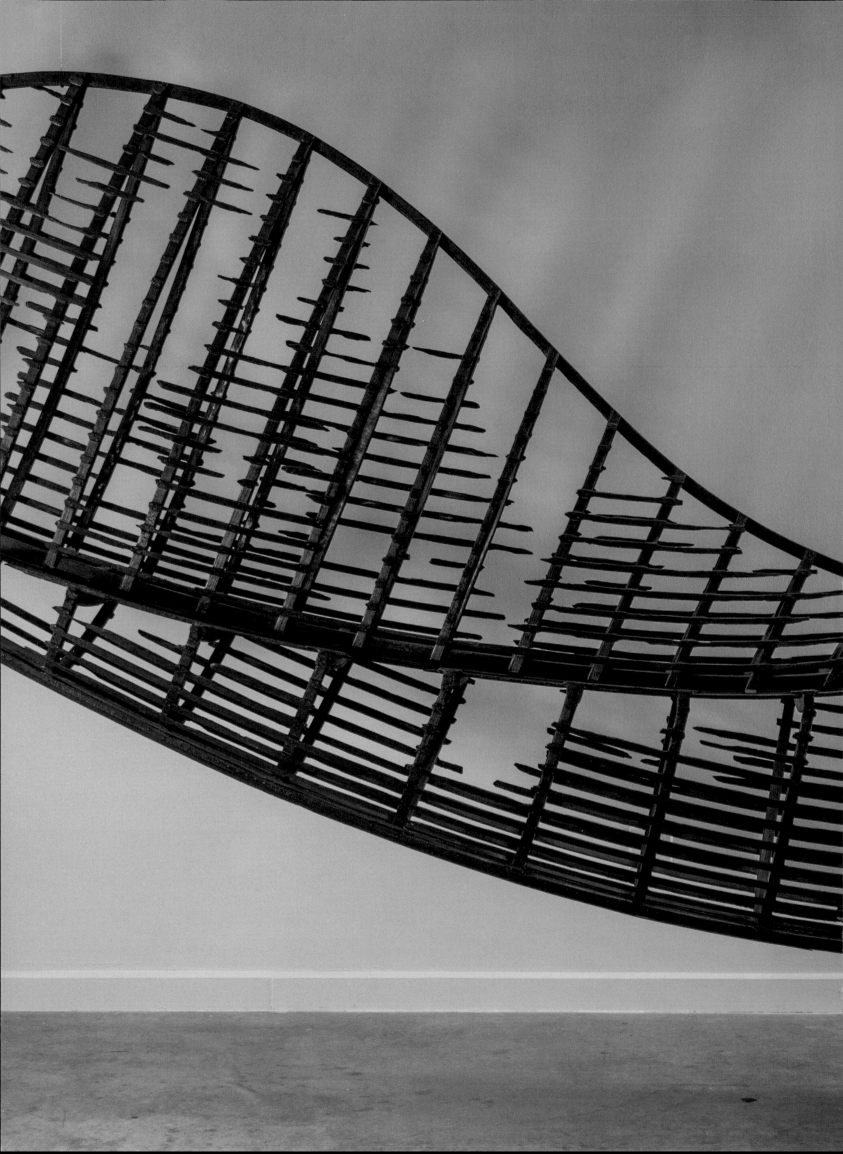

Dustin Farnsworth

A STRANGE INHERITANCE

styx/vodun
(detail; see pp. 72–73)

The charred shell of an abandoned theater stage . . . a crumbling water tower perilously close to collapsing upon itself . . . an open-frame funerary vessel containing black-dipped carnations. These are the visions of Dustin Farnsworth that coalesce into powerful statements on the societal, cultural, and familial weight put upon tomorrow's generation. Working primarily in wood, Farnsworth creates intricately detailed sculptural works imbued with haunting storylines and nested layers of meaning — from abstract geometrical forms and sculptural portraits to miniature theaters and kinetic works. As our persuasive narrator, he produces collective portraits of communities shaken by crisis and wary of the future, like those devastated by economic decline, police brutality, and high school shootings.

Farnsworth was born and raised in Lansing, Michigan, and witnessed first-hand the impact of the 2008 economic crisis on industries in the region. At the time, he was studying for his BFA at Kendall College of Art and Design in nearby Grand Rapids. "The glory days, or even the talk of those days of Detroit, had long passed before my youth. Its ruins stood as an example of what could come, but I didn't have an idea of what was lost until that wave hit my hometown."[1] Much of Farnsworth's early work was profoundly influenced by what he describes as the failing of nondiversified economies in the rust belt, specifically of Michigan's car industry (fig. 1). "I saw images of these factories that had produced the sounds and cadence of life in Lansing, now bare and desolate. My home was just a few blocks from GM's Plant One and was nestled between two drop forges that supplied tooling."

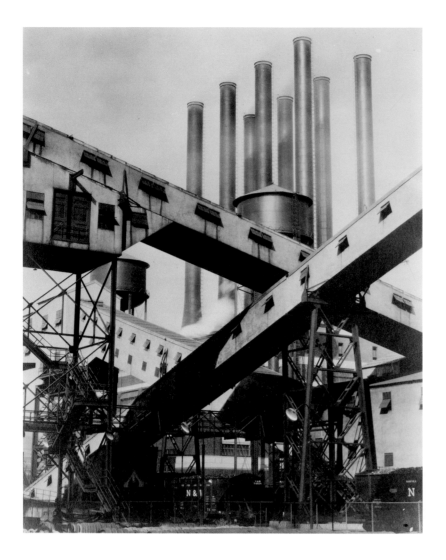

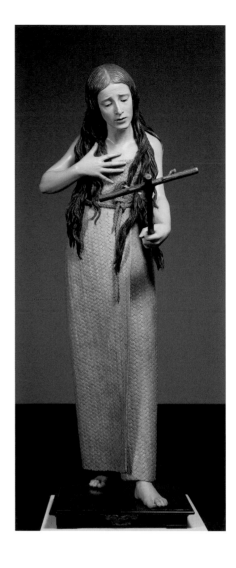

FIG. 1

Charles Sheeler, **Criss-Crossed Conveyors at Ford Rouge Plant**, 1927, gelatin silver print. The Henry Ford

FIG. 2

Pedro de Mena, **Mary Magdalene Meditating on the Crucifixion**, 1664, polychrome wood. Museo Nacional del Prado, Madrid

Other Michigan-born artists have drawn upon the imagery, materials, and mappings of industry in their craft — like ceramicist Steven Montgomery's large-scale decaying mechanical fragments or Norwood Viviano's use of glass to explore the relationship between manufacturing and population change. Farnsworth's reflections focus on the way industrial infrastructure mirrors society's growth and decline, and the aftermath it leaves behind for younger generations. The study of why civilizations end, like Jared Diamond's 2005 *Collapse: How Societies Choose to Fail or Succeed*, has influenced some of these propositions within Farnsworth's work. Diamond examines historical case studies of various societies, ranging from the Mayan civilization to the people of Easter Island. He finds a common thread in mankind's recurring habit of destroying itself by overexploiting its resources, which he flagged as "what may lie ahead for us in our own future."[2] Through his work, Farnsworth imagines how the next generation feels about inheriting a world from those who have "used resources without regulation or thought for the future; generations living only for their time and not for a collective future."

Farnsworth's medium can be just as volatile as his subject matter, which he uses to shape emotions and convey drama.

Our relationship with wood is primal. It's a living material that we connect with daily, it shelters us, and its combustibility keeps us warm. We think of it as stable but it constantly seeks equilibrium with its surrounding atmosphere, swelling and shrinking. Its markings and inconsistencies are similar to our own flesh. Its instability requires special skill and consideration, yet wood also retains a fragility and impermanence.

The exaggerated emotions Farnsworth carves reflect his interest in the religious statuary of seventeenth-century Spain, like works by Andalucían master sculptors Pedro de Mena (fig. 2) and Juan Martínez Montañés. His sculptural portraits aspire to elevate his figures, mainly marginalized youth, to subjects worthy of contemplation, akin to religious figures. These intentions hark back to a formative experience Farnsworth had as a child when he saw Diego Rivera's *Detroit Industry* murals at the Detroit Institute of Arts: "The experience of the murals is religious, but its subject matter was the working class. All backs are bent in the strain of labor, and it speaks in the tongue of the people. I've seen amazing works in Rome, but this work holds its own. That space is a cathedral."

The carefully sculpted figures in *Promontory*, *Succession*, and *The Understood Weight* (figs. 3–5) made in 2013 and 2014 are each surmounted with cruel crowns — architectural structures that blend memories of extant buildings with fragments of imagination and cinematic conjecture. These semi-fictional edifices conjure everything from grain elevators and water towers to theaters and sports stadia — building types associated with resource excess and communal entertainment, evoking work and leisure, bread and circuses; pride and greed, lust and gluttony. Their gnarled and crumbling surfaces suggest the weathered patina of abandoned buildings that were once glittering examples of urban infrastructure, social investment, and civic pride. The headdresses, bearing the weight of human sin, heavy with knowledge of the future, bear down upon the shoulders of young people left to face the realities of tomorrow.

The character in *Promontory* seems on the verge of toppling over from the weight of her headdress. Areas of the building's exterior have been burned away to nothingness, barely connected by slivers of charred timbers. Her expression betrays emotions of anger, frustration, and ultimately resignation. The structural

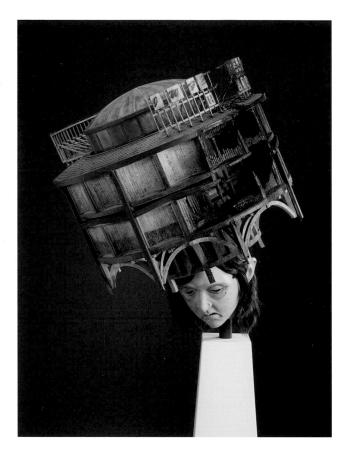

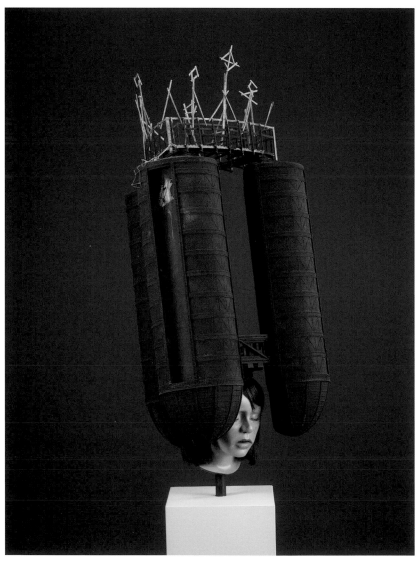

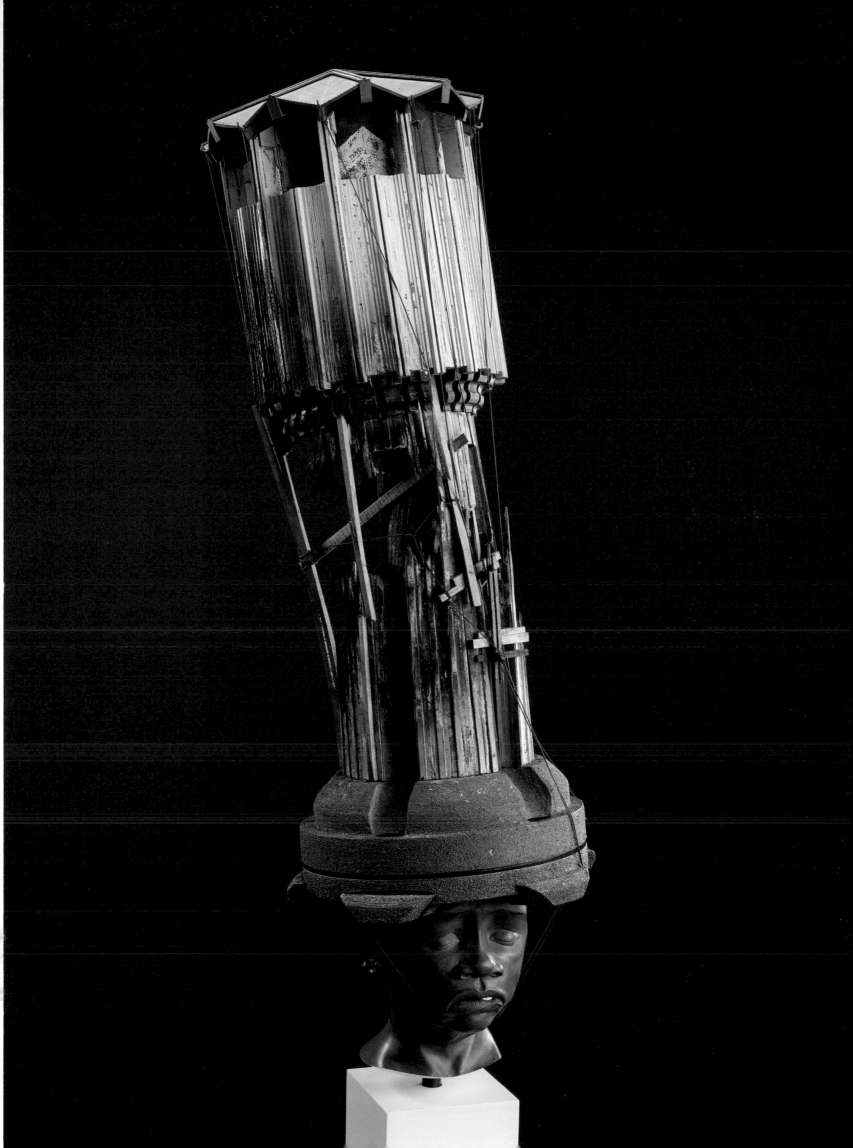

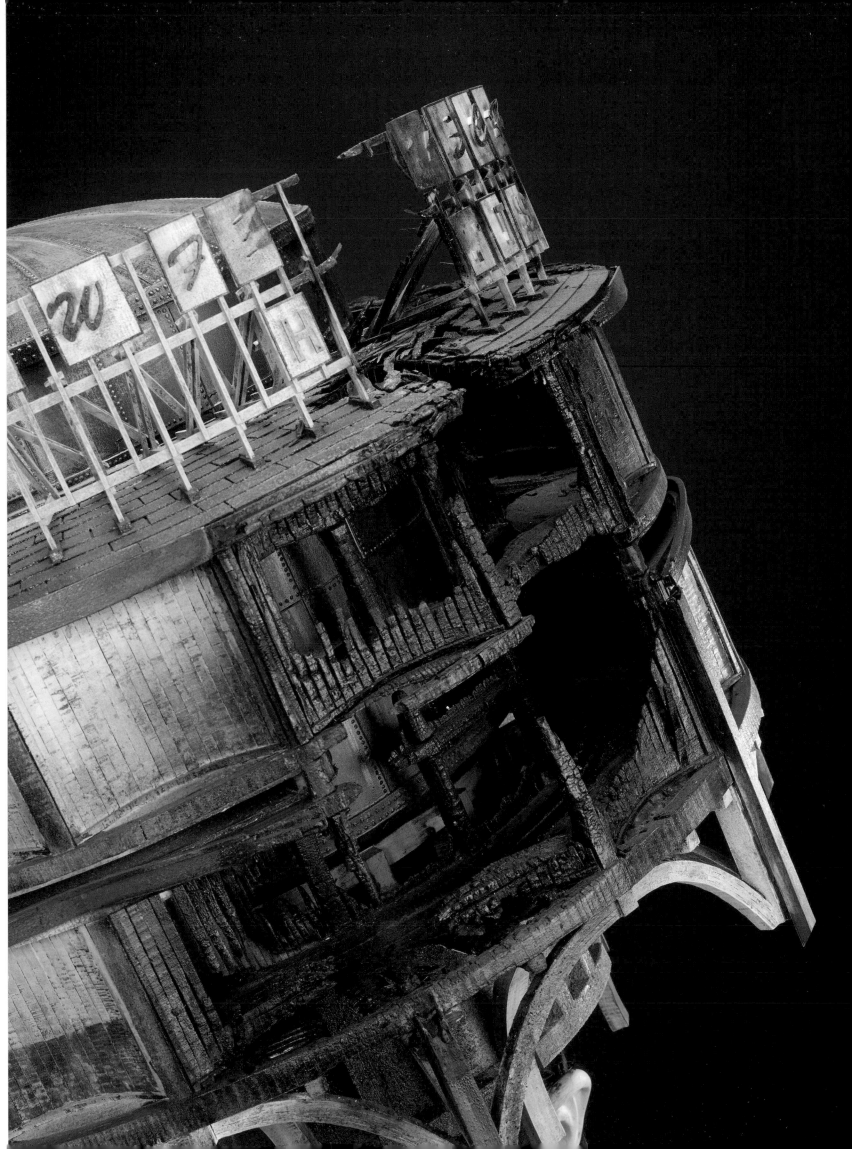

FIG. 9

Promontory
(detail; see p. 64)

The seeds of these more abstract forms can be seen in *Maunder* (fig. 10), where the head and neck of a young girl is adorned with a structure that looks like a futuristic version of a seventeenth-century Dutch lace ruff. According to Farnsworth, the work takes its cue from the massive concrete "acoustic mirrors" constructed along the southern coast of England in the years leading up to the Second World War. These experimental parabolic structures, also known as "whisper dishes," were designed before the advent of radar as an early warning military defense system, to detect the sounds of incoming enemy aircraft. The title, *Maunder*, is a word meaning to babble incoherently. For Farnsworth, this piece references the immense overload of information that young people contend with today, and how challenging it can be to process the overwhelming noise and static. A sequence of weights hangs from *Maunder*, pulling down our protagonist's head (fig. 11), emphasizing its heavy burden. The array of cords supporting the weights alludes to steel cable supports found on a suspension bridge, resembling the mass-scale infrastructure seen in Farnsworth's later pieces, like *Promontory*.

All remnants of literal architectural representation have been distilled into a pure geometric structure in *A More Sophisticated Form of Chaos* (fig. 12). The result resembles a religious halo of sorts. Lightly structured yet still overpowering the figure, who seems to be lost in agonizing thought, the abstract form maintains an allusion to infrastructure, subtly referencing traces of aeronautical engineering and large-span bridges. In *The King Is Dead* (fig. 13), Farnsworth's desire to "edit away information" is applied to the physicality and mentality of the portrait as well as the structure. The character is left androgynous, without hair, and as with some previous works, the eyes are absent, allowing the viewer to play the protagonist. The face appears more as a mask — lacking the emotion of previous portraits — and is smeared with a thick white pigment, applied like a form of battle paint. As with *A More Sophisticated Form of Chaos,* the notional surface cladding has been removed from the architectural form to create further anonymity. Farnsworth takes even more away by burning the structure, resulting in a form that resembles charred, abandoned ship hulls — invoking another extinct industry in Detroit, shipbuilding, which had thrived for decades during the late nineteenth and early twentieth centuries. The burnt headdress attaches to the figure like an animal trap, and becomes an extension of the face itself. Farnsworth considers this cage-like form "a charcoal drawing in space . . . many of the sections were burnt away completely to create a lost and found contour; a place for the mind to complete the form."

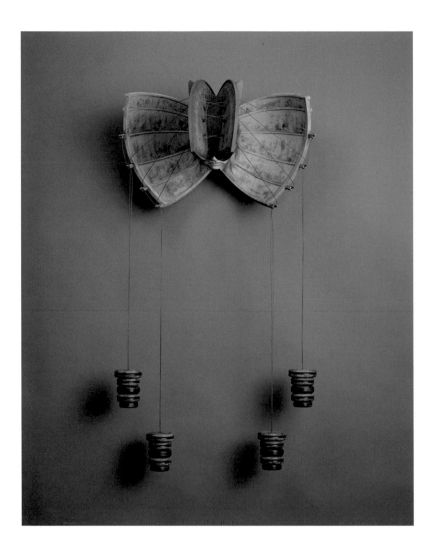

FIG. 10

Maunder, 2012, basswood, poplar, bendable plywood, cable, medium-density fiberboard, hair, and various polychrome. Collection of Lorne Lassiter and Gary Ferraro

FIG. 11

Maunder (detail)

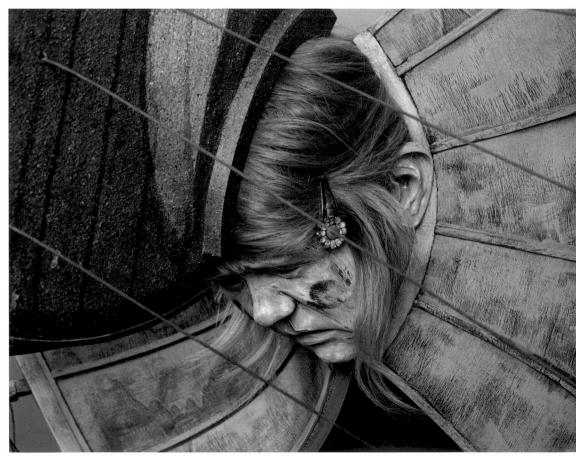

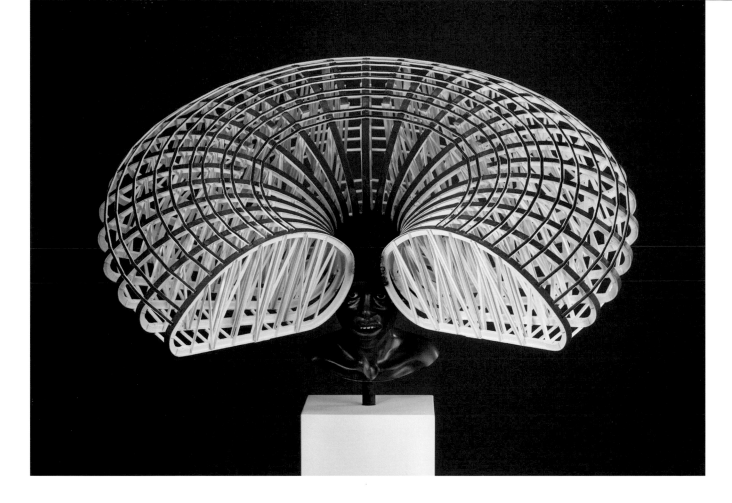

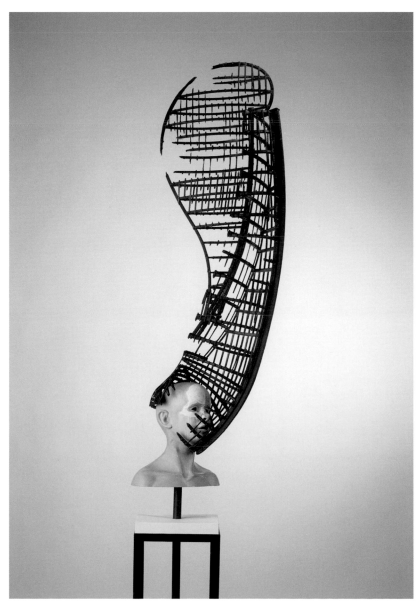

With his most recent pieces, Farnsworth separates his portraits from his headdresses completely, creating an entirely new body of work. Greatly impacted by recent artist residencies in Madison, Wisconsin, and Charlotte, North Carolina, his work has become embedded with a charged sense of social response and community activism. Farnsworth arrived in Madison in 2015 to find "an entire community rifled with mourning, anger, and frustration" after the death of Tony Robinson, an unarmed nineteen-year-old shot by a Wisconsin police officer. A year later, his residency in Charlotte coincided with the aftermath of the shooting of Keith Lamont Scott, also by a police officer. In both cities, Farnsworth witnessed community protests and contentious debates about race, civil rights, and police oppression. The resultant series of works explore the notion of memorialization, whether of people or of a city, while also serving as calls to action.

During his Madison residency, Farnsworth met fellow resident artist Eric Adjetey Anang, a third-generation Ghanaian sculptor and carpenter of fantasy coffins, elaborate and functional works of art custom-made to reflect a person's life and passions. Conversations the two artists had about the tragic shooting of Tony Robinson, gun violence in their respective countries, and the different ways cultures mourn or celebrate death became the driving force behind *styx/vodun* (fig. 14) and *XLIII* (fig. 15). The title of the first references Western European and West African traditions of spirituality and death — Styx, the river of the underworld in Greek mythology, and vodun, also referred to as voodoo, the religion derived from African polytheism and ancestor worship. It exists as a large, suspended funerary vessel containing several hundred carnations dipped in black paint (fig. 16). The form echoes the maple seedpod cage of *The King Is Dead*, while the black flower petals reference the narrative played out on the theater stage in his earlier work, *The Bones Of* (fig. 17). The second work, *XLIII*, commemorates the number of young lives lost to police shootings in 2015 alone, the number of deaths revealed through its title. Tipped back, and perched precariously on

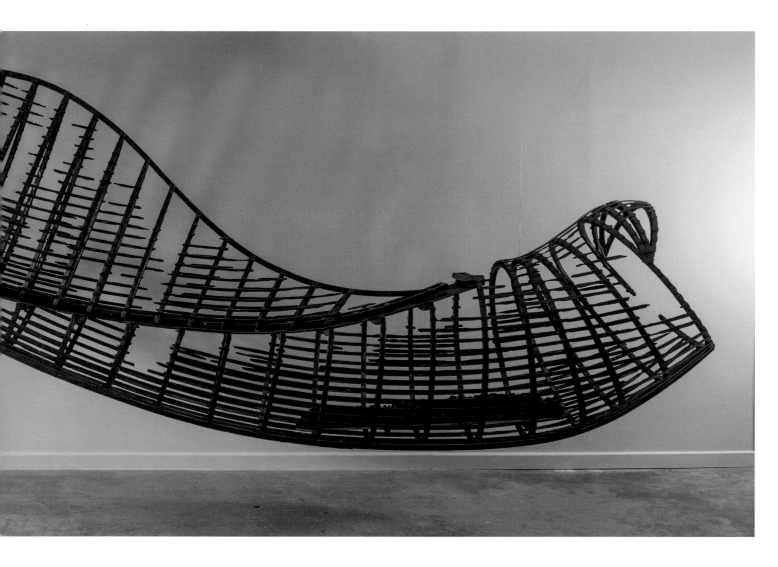

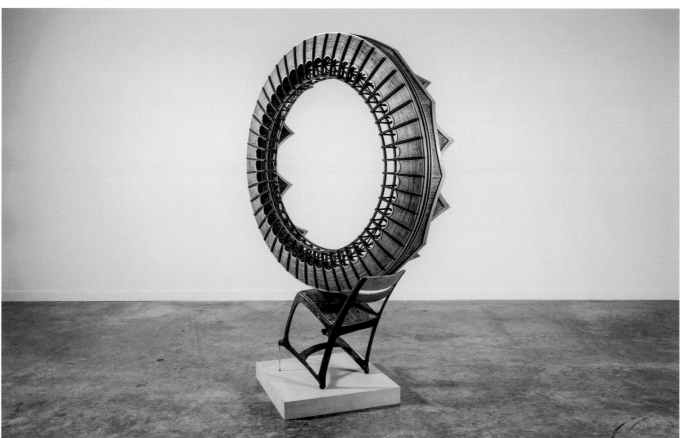

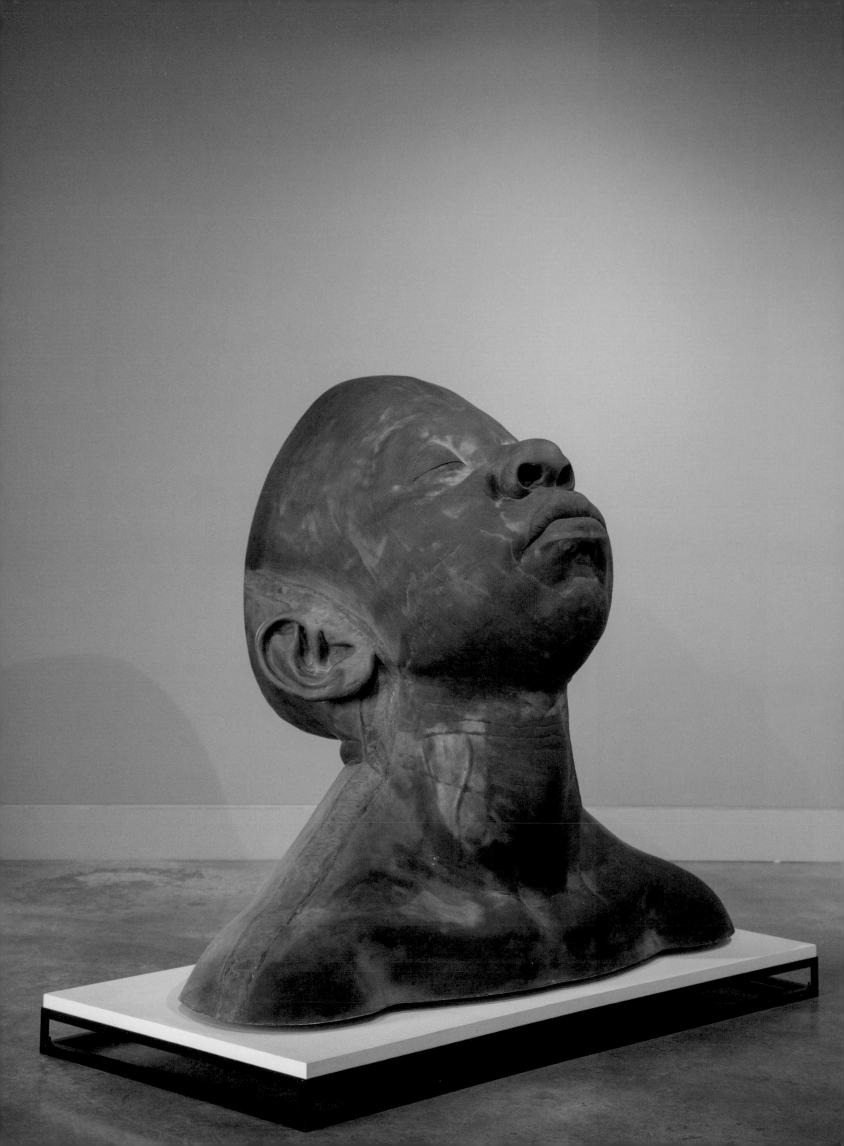

Opposite page
FIG. 18

**The Reconstruction
of Saints** (in progress),
2018, Aqua-Resin and
polychrome. Collection
of the artist

FIG. 19

**The Reconstruction
of Saints** (mask), 2018,
gold leaf, Aqua-Resin,
fiberglass, foam, and
plywood. Collection
of the artist

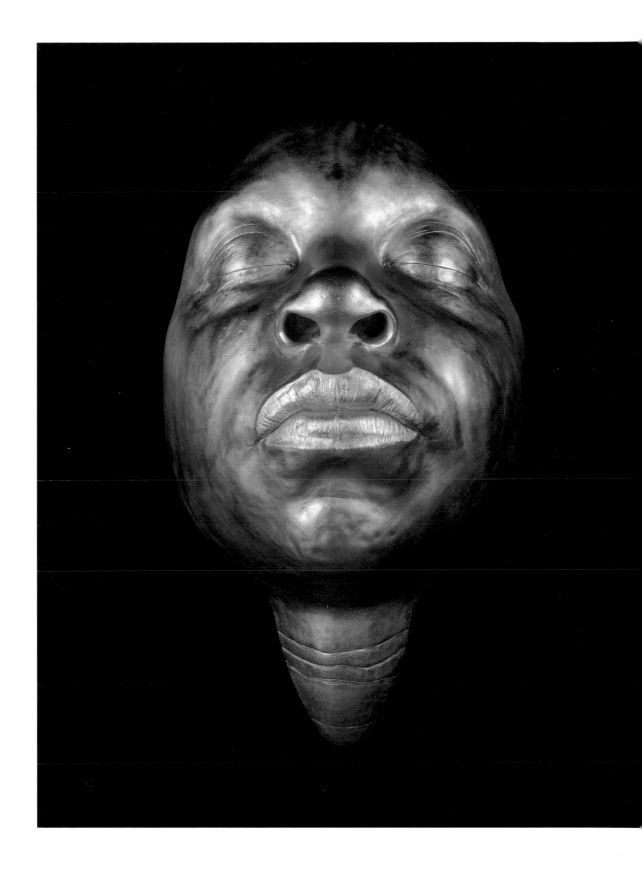

Stephanie Syjuco

PATTERN RECOGNITION

**Antebellum South
(Simplicity)**
(detail; see p. 89)

What does it mean to be American? How do we look? What does it mean to look as though we belong? Nearly every endeavor Stephanie Syjuco undertakes is motivated by a question, and depends on the viewer to provide part of the answer, or to ask a question of themselves. Her work questions everything from notions of identity, to broader cultural and economic concerns, such as, what is the value of labor? Why are logos important to consumers? What makes an object counterfeit? She is fascinated by systems, so her work usually involves multiples in various forms, from off-the-rack clothing to crocheted knock-offs of luxury accessories and ersatz pieces of currency. Her projects tend to capture the friction that occurs where a standardized entity meets an individual (or many millions of individuals). Every person who views or interacts with one of Syjuco's projects will experience it differently, depending on their own role in the larger global networks of fashion, consumerism, money, and labor. Running through each of her projects is an emphasis on context, and how we see things differently when the backdrop changes.

Syjuco's inclusion in the 2018 Renwick Invitational may come as a surprise. When asked to comment on the meaning and significance of presenting her work at the Renwick for this exhibition, Syjuco wrote: "The fact that I am not a traditional craft artist but a visual artist interested in how shifting identities are fictionalized and play into the narrative of who is and who isn't 'American' is really powerful for me. As someone included in a craft show, I claim the word 'craft' as a verb to manufacture a complicated and contradictory identity as

an American."[1] An installation artist with a strong interest in social practice projects, Syjuco is more apt to create a communal workspace or an elaborate mise-en-scène inside an exhibition space than a series of discrete objects on pedestals. She teaches in a university art department (at the University of California, Berkeley) and not in a craft or material studies program. She does not work closely with any of the well-known craft organizations — ceramics residency programs, woodturning centers, or glass studios — with which other Renwick Invitational artists are often involved. It's fair to say that Syjuco exists parallel to the institutional craft ecosystem in America rather than within it. Since the craft world is accustomed to leading with material, it's worth asking what Syjuco's medium is — if other artists are devoted to glass or clay, batik, or even recycled film strips, we might say that Syjuco's medium of choice is pattern.

Recently, Syjuco has created a series of works that use patterns found within systems, standards, and typologies. Craft artists — for lack of a much-needed better term — already engage in the types of systems and typologies Syjuco exploits. Today's potters and weavers make their own versions of recognized forms using methods, technology, visual motifs, styles, and even modes of display that are known quantities both within their fields and far beyond. Pottery, for example, has its own instantly recognizable ancient Greek-inspired emoticon.[2] What makers communicate when they create something new is symbolic as much as it is aesthetic: an object can be understood, if nothing else, as an example of its *type*. Syjuco is exploring ways to apply this logic to her multidisciplinary practice. In her work, the categories and typologies we use to understand objects cannot be uncoupled from the way we categorize people. Thoughts on gender, race, nationality, and status — ways we identify ourselves and see others — are quite literally woven into the fabric of her projects.

To play with assumptions influenced by such typologies, Syjuco created her 2016 photographic series *Cargo Cults*, stemming from her earlier 2013 installation *Cargo Cults: Object Agents* (fig. 1).[3] She bought off-the-rack garments from mass-market retailers including Forever 21, H&M, American Apparel, Urban Outfitters, Target, the Gap, and others, and then styled them on herself to evoke the clothing depicted in nineteenth- and early twentieth-century Western portraits of exotic subjects in the Middle East, Asia, and Africa (figs. 2 and 3). She posed against a black-and-white backdrop inspired by "dazzle camouflage," a graphic technique that was used on battleships during World War I to confuse the aim of enemies. After the photographs were made, she returned all the garments to their retailers.

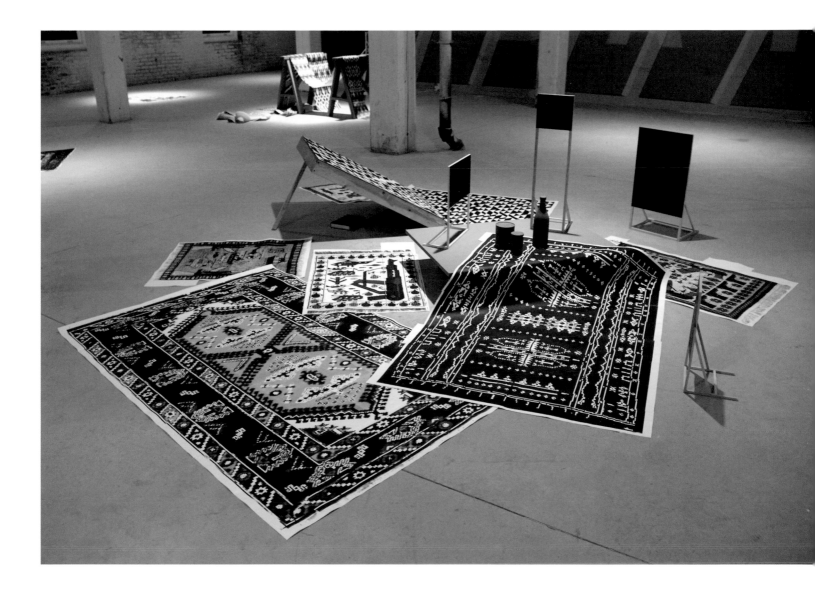

Cargo Cults asks the viewer to question their assumptions: What kind of exoticism are we viewing when we see a woman of color wearing "ethnically" styled clothing? That the clothing she chose to use is from twenty-first-century American retailers and made overseas — probably very far away, at that — underscores the notion of camouflage, and the disruption of our ability to situate and classify the subject being depicted.

To explore other ways information and identities can be masked, Syjuco has been using the artistic possibilities of digital editing tools, like the special effect of chroma-key, used in film and video post-production to "drop out" a particular color range and transform a background. The effect is often used for weather newscasts, to make meteorologists appear in front of a computer-generated weather map, which is in reality just a blue or green screen, or to insert an actor into a digitally enhanced scene. Syjuco's *Chromakey Aftermath 2* (fig. 4) uses this concept to make a statement on how information can be edited or hidden from

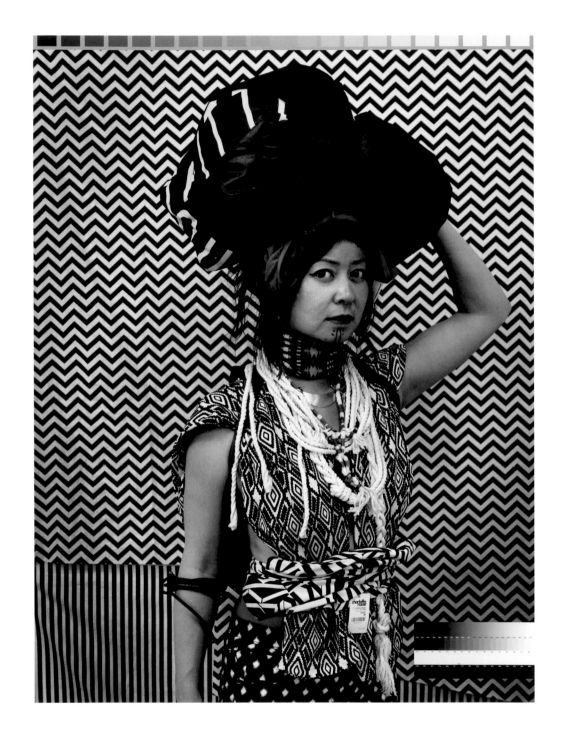

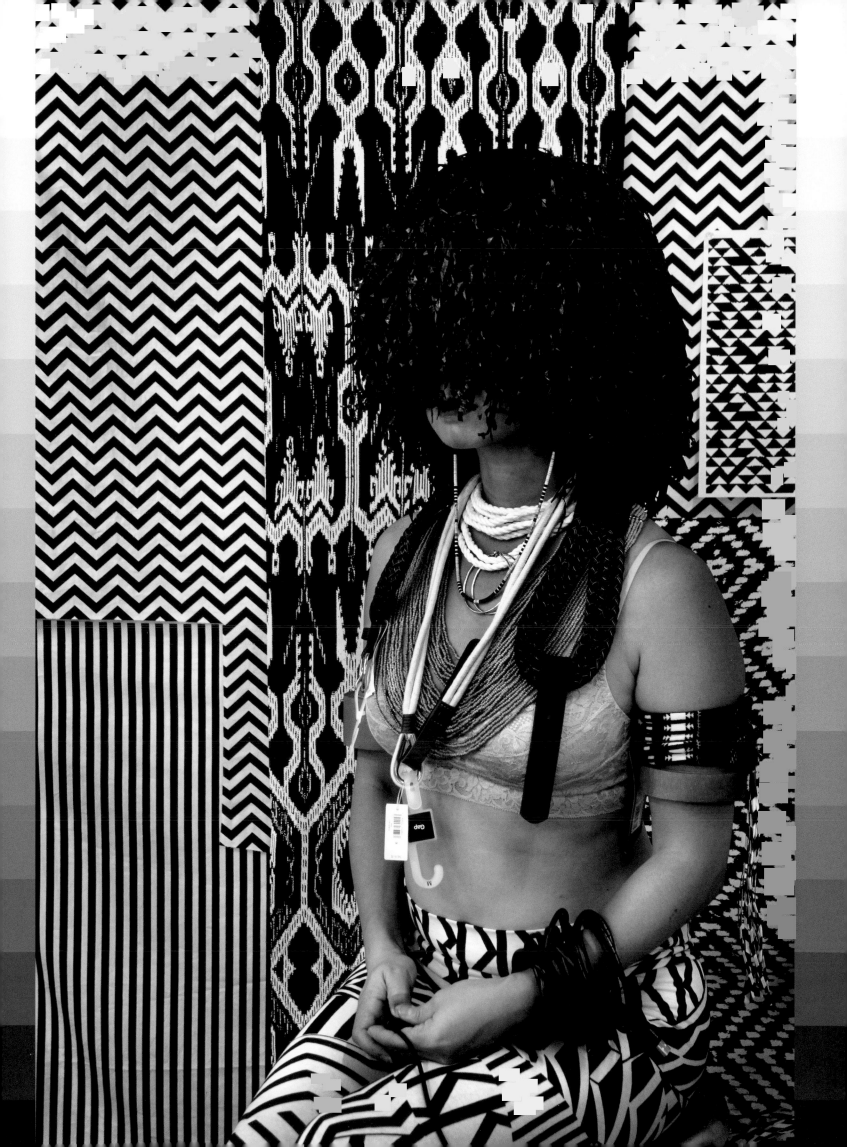

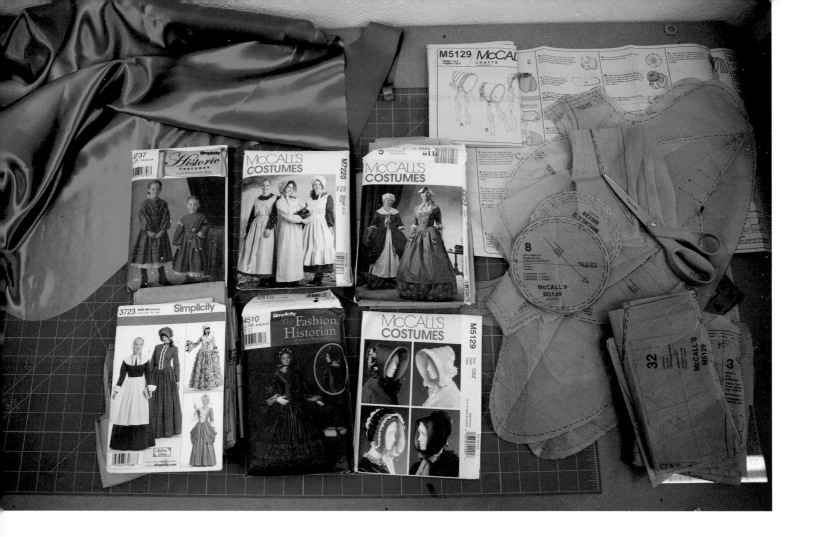

FIG. 5

Materials used for
The Visible Invisible
project

Opposite page,
left to right
FIG. 6

**The Visible Invisible:
Plymouth Pilgrim
(Simplicity)**, 2018, cotton
muslin chromakey back-
drop fabric, ribbon, lace,
buttons, and display form

**Antebellum South
(Simplicity)**, 2018, cotton
muslin chromakey back-
drop fabric, polyester
satin, crocheted cotton,
ribbon, lace, buttons, and
display form

**Colonial Revolution
(McCall's)**, 2018, cotton
muslin chromakey back-
drop fabric, ribbon, lace,
buttons, and display form.
All collection of the artist

our view. It depicts a monochromatic green assemblage of the kinds of detritus that might be left after a protest — banners, poles, flags, clothing — all rendered in "drop-out" green, suggesting that the entire endeavor and its "props" have been digitally selected and deleted, perhaps from an imagined news broadcast.

Textiles and the needle trades have always been central to Syjuco's practice, and by studying the history, social significance, and aesthetics of sewing patterns produced by companies like McCall's and Simplicity (fig. 5), she found that in both the world of film production and in the domestic realm of sewing, people and objects can be rendered as "cutouts," or stand-ins symbolizing a "type." Inspired by this premise, Syjuco is working on fabric garments using what she calls "chromakey fabrics," sewing recognizable period costumes in bright green (fig. 6). Visitors to historic sites like Independence Hall in Philadelphia, or the Governor's Palace in Williamsburg, Virginia, will instantly recognize the tricorn hats, ruffled caps, and cloaks of the historical interpreters dressed in colonial garb. Different gowns, suits, bonnets, and hats could likewise signify Massachusetts pilgrims, people living in the Civil War era, or covered wagon pioneers. Those who grew up with American Girl dolls may even have biographies and narratives at the ready to flesh out the different archetypes. For future projects, Syjuco envisions introducing a twist to this constellation of recognizable cutouts by using boldly

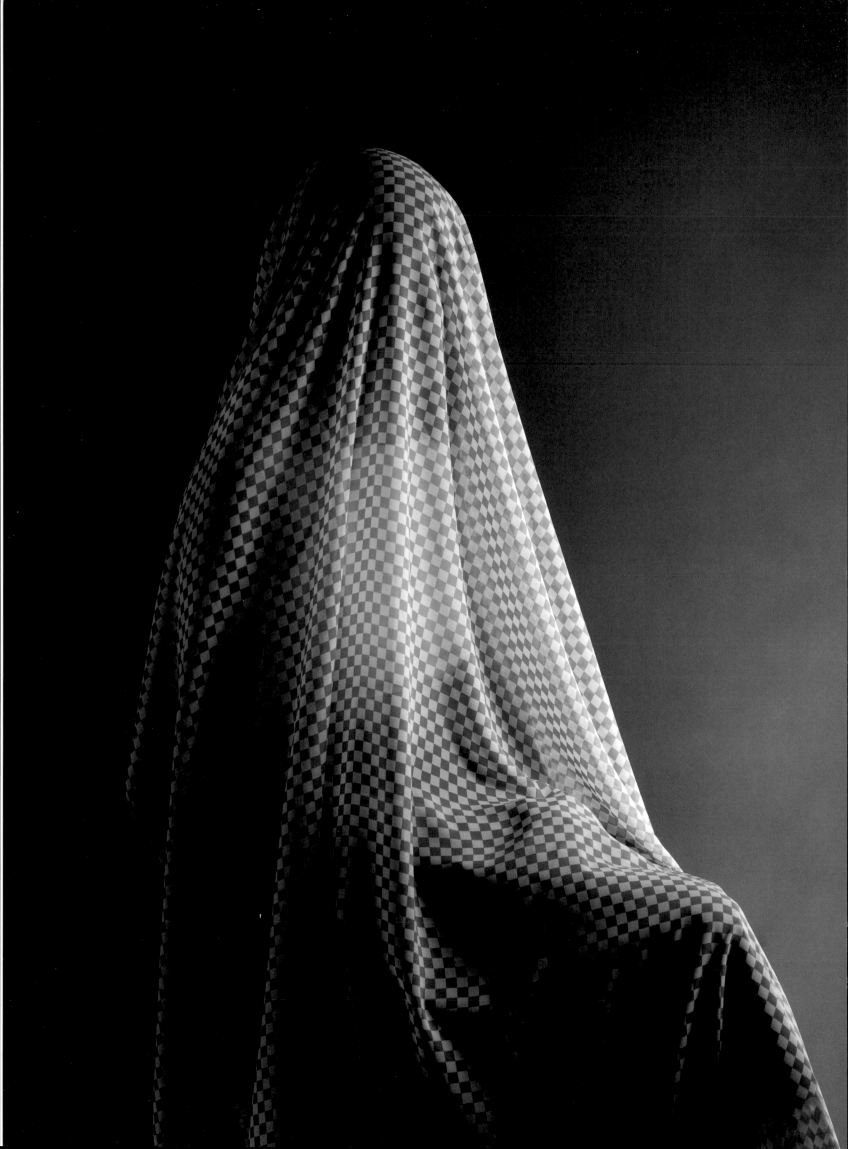

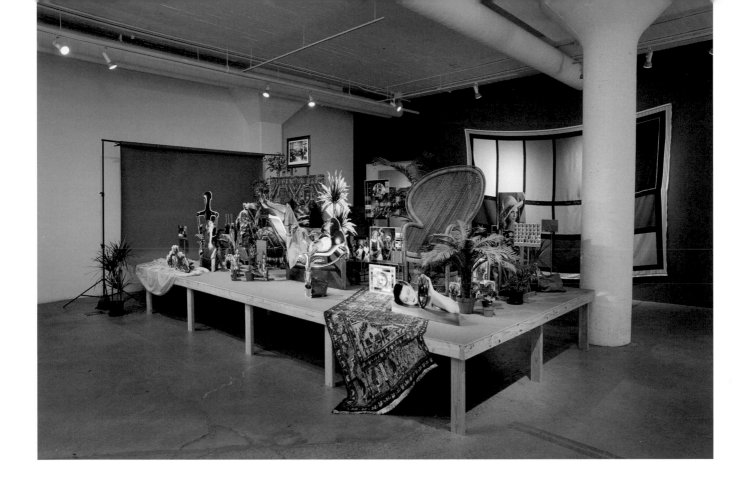

Opposite page
FIG. 10

**Total Transparency
Filter (Portrait of N)**,
2017, archival digital print.
Collection of the artist
and courtesy RYAN LEE
Gallery, New York

FIG. 11

**Neutral Calibration
Studies (Ornament +
Crime)**, 2016, wooden
platform, neutral grey
seamless backdrop paper,
digital adhesive prints on
laser-cut wooden props,
dye-sublimation digital
prints on fabric, items
purchased on eBay and
craigslist, photographic
prints, artificial and
live plants, and neutral
calibrated gray paint.
Collection of the artist
and Nion McEvoy

The same pattern drapes over one of these portraits in *Total Transparency Filter* (*Portrait of N*) (fig. 10), suggesting a new way to consider the comfort and protection of a quilt. The young woman's identity is totally obscured, but she is an undocumented American who was able to complete her college degree as a DACA (Deferred Action for Childhood Arrivals) recipient, which, as of this writing, has been terminated by the Trump administration and is under litigation. The pattern in the photograph echoes the dense "dazzle camouflage" graphics that Syjuco employs in *Cargo Cults*, but it is subtler and softer, even cozy. There is perhaps no textile as quintessentially American as a quilt. Thus, Syjuco's checkerboard pattern is at once an *absence*, in the Photoshop sense, a digital non-entity waiting to be filled in at some later date (the subject's fate and identity as an American unknown), and a historic *presence*, in the American textile sense, an heirloom that represents domestic tradition, skill, and national identity.

Syjuco's 2016 project *Neutral Calibration Studies* (*Ornament + Crime*) (fig. 11) further questions notions of cultural and political identity. It takes the form of a classic still life, organized around color calibration charts, the kind that photographers use to determine which colors are "neutral" or "correct." In the early to mid-twentieth century, in photography as in so many other aspects of visual culture, "neutral" was Caucasian. On a large platform, a cacophonous assemblage of objects and images compete for attention, many of them dating from the period of time in which colonialism was beginning to unravel and modernism

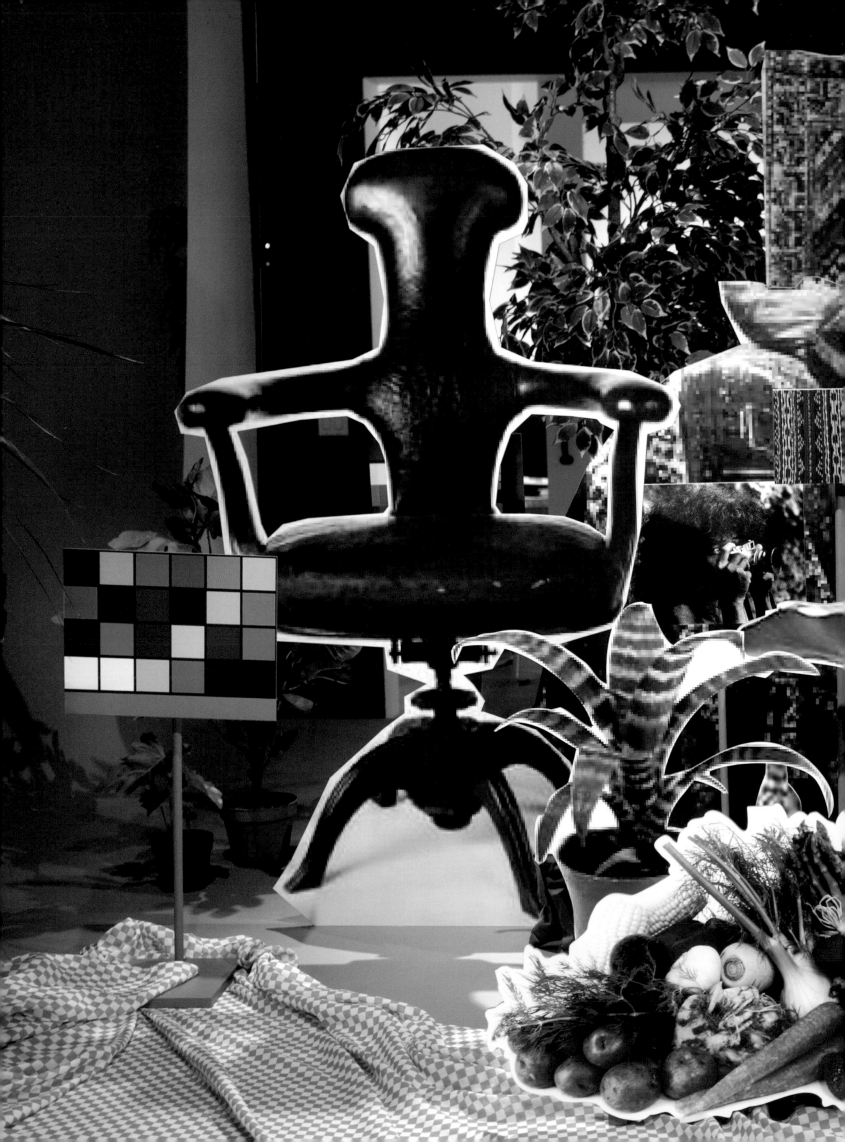

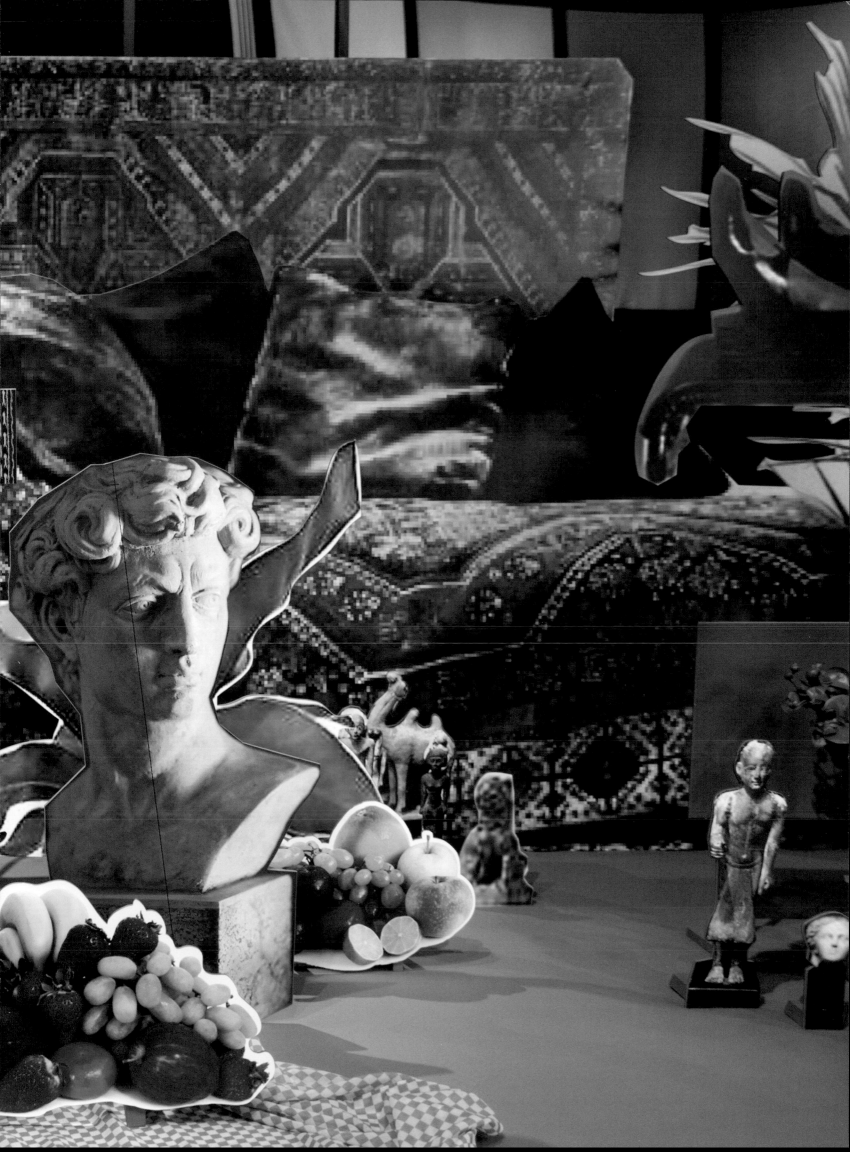

was taking shape. Central Asian rug patterns downloaded from the Internet and blown up to appear pixelated hang above a reproduction of Freud's office settee in Vienna (fig. 12). The French modernist designer Charlotte Perriand reclines on a chaise longue designed by Le Corbusier, and Man Ray's photograph of a white model posed with an African mask is framed by faux potted plants. Other details, like a traditional Filipino rattan butterfly chair, are painted neutral gray, as is the entire back side of the installation (fig. 13). The question of what is "neutral" and what is "colorful" or "colored" is as loaded as it gets in contemporary America.

Syjuco's use of pattern has a third effect, beyond the metaphorical and the aesthetic: her community-based projects often involve group crafting sessions, or she might invite visitors to an exhibition to participate in a work. For her 2008 Counterfeit Crochet Project, she created a website inviting people with crochet skills to create handmade faux designer handbags, like those made by the luxury houses of Chanel, Fendi, and Prada (fig. 14). The crocheters were instructed to search for low-resolution images of luxury bags online, then create a crocheted knock-off based on that image. Due to both the technique being used and the

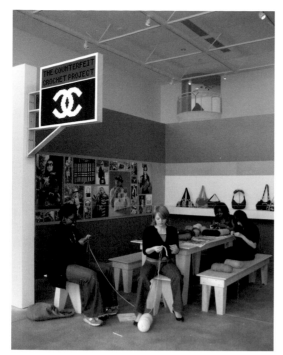

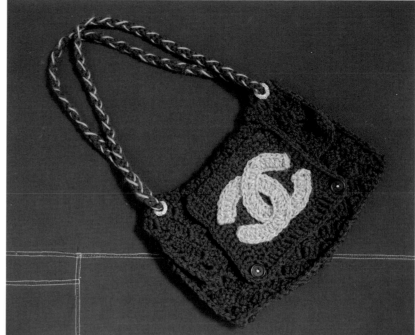

pixelation of the source image, the resulting "counterfeit" bags looked only faintly like their authentic counterparts (fig. 15). By working with volunteers, Syjuco was able to add a dimension of labor critique to a piece that addresses the production of fashion, both high and low. "Crochet is considered a lowly medium," she writes, "and the limitations imposed by trying to create detail with yarn takes advantage of the individual maker's ingenuity and problem-solving skills."[4] In this work, the participation of others is as crucial to Syjuco's piece as the materials themselves and the ideas they manifest.

Patterns can be found in the ways we understand our identity and nation-hood, and how we see ourselves and each other in a country whose relatively short history is shaped by contradictory elements. Our national story includes cherished narratives of hand-sewn flags and hand-built log cabins, of military might and global dominance in manufacturing — and the painful ebb of that dominance as we struggle to pivot into an unknown future. With all of that in mind, and in the rich historical and contemporary context of the Renwick Gallery, an "American craft calibration study" is as timely as ever. Syjuco's inclusion in this year's Invitational expands the reconsideration of what American craft means — and who American craft artists are — furthering the Renwick's explo-ration into the evolution of craft in the twenty-first century. SARAH ARCHER

Gray Scale Calibration Chart, 2016
dye-sublimation print on polyester satin
78 × 80 in.
Collection of billy ocallaghan &
mark sanford gross

Neutral Calibration Studies (Ornament +
Crime), 2016
wooden platform, neutral grey seamless
backdrop paper, digital adhesive prints on
laser-cut wooden props, dye-sublimation
digital prints on fabric, items purchased on
eBay and craigslist, photographic prints,
artificial and live plants, and neutral
calibrated gray paint
10 × 20 × 8 ft.
Collection of the artist and Nion McEvoy

Chromakey Aftermath 2 (Flags, Sticks,
and Barriers), 2017
archival pigment print
20 × 30 in.
Collection of the artist and courtesy
RYAN LEE Gallery, New York

Total Transparency (Background Layer
Bleed), 2017
hand-sewn quilting cotton
13 ft. 4 in. × 27 ft. 3 in.
Collection of the artist and courtesy
RYAN LEE Gallery, New York

Ungovernable (Hoist), 2017
sewn muslin and steel armatures
approx. 103 × 98 × 30 in.
Collection of the artist and courtesy
RYAN LEE Gallery, New York

The Visible Invisible: Antebellum South
(Simplicity), 2018
cotton muslin chromakey backdrop fabric,
polyester satin, crocheted cotton, ribbon,
lace, buttons, and display form
approx. 69 × 60 × 60 in.
Collection of the artist

The Visible Invisible: Colonial Revolution
(McCall's), 2018
cotton muslin chromakey backdrop fabric,
ribbon, lace, buttons, and display form
approx. 69 × 48 × 48 in.
Collection of the artist

The Visible Invisible: Plymouth Pilgrim
(Simplicity), 2018
cotton muslin chromakey backdrop fabric,
ribbon, lace, buttons, and display form
approx. 69 × 48 × 48 in.
Collection of the artist

Dimensions are given as height × width × depth.

Image Credits ——————

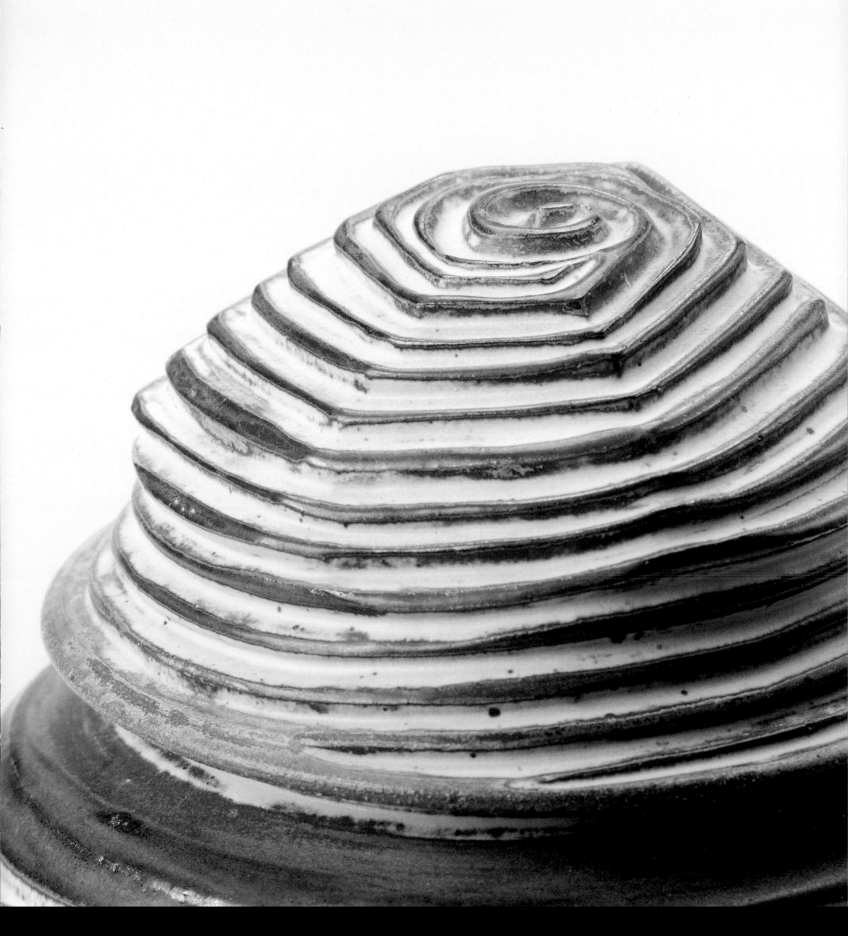